DWYER'S IRELAND
A VIEW FROM ABOVE

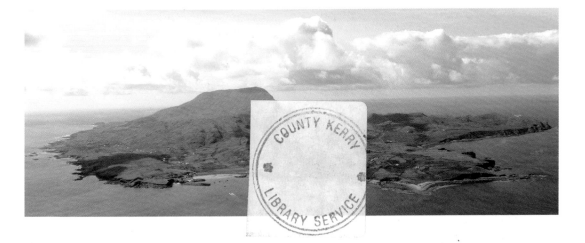

KEVIN DWYER

The Collins Press

First published in 2010 by
The Collins Press
West Link Park
Doughcloyne
Wilton
Cork

British Library Cataloguing in Publication Data
Dwyer, Kevin, 1944-
Dwyer's Ireland : a view from above.
1. Ireland–Aerial photographs. 2. Ireland–Pictorial
works.
I. Title
914.1'5'00222-dc22

ISBN-13: 9781848890633

Typesetting by The Collins Press
Typeset in Adobe Garamond Pro
Printed in Malta by Gutenberg Press Ltd

Photographs
Prints/enlargements can be purchased from:
Kevin Dwyer, Blue Cottage, Ballycrenane, Cloyne, Co. Cork, Ireland
email: photos@kevindwyer.ie
www.kevindwyer.ie

Front cover: St Patrick's Purgatory on Station Island, Lough Derg, County Donegal.
Front flap: A monastic site on Illauntannig, Magharee Islands, County Kerry.
Back cover (clockwise from top left): Charles Fort, Kinsale, County Cork; Clare Island, County Mayo; the Lakes of Killarney, County Kerry; O'Connell Street and Henry Street, Dublin; Donegal coastline and Gola Island.

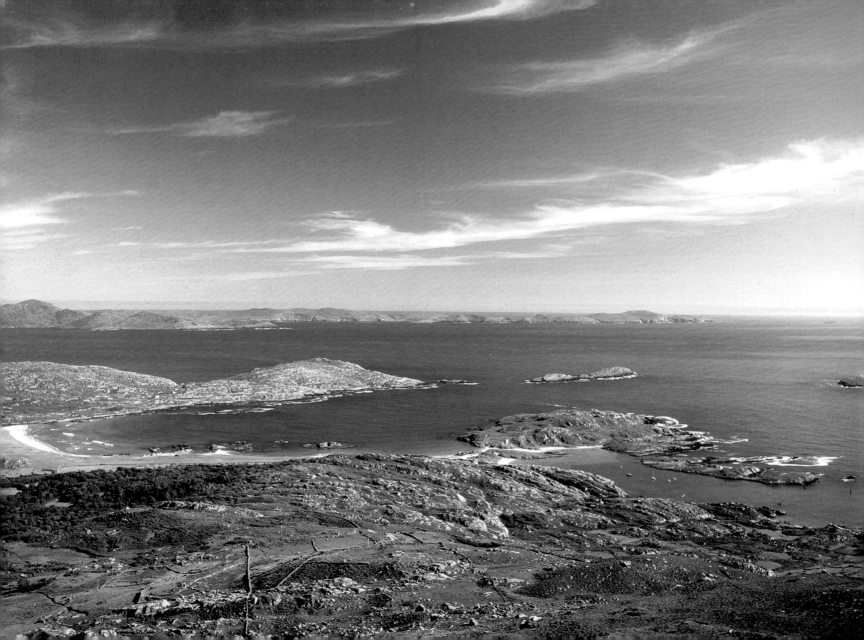

Introduction

IN THE WORLD of human resources it is nearly always stated that an applicant for a position is required to have at least two or three years' experience in the relevant field. I have always been mystified as to how an individual is expected to acquire such experience in the first instance.

I was asked in 1989 to submit a sample of photography which I had taken from the air. This posed quite a problem because I had never taken any. I had in my library a photograph of Derrynane and the Kenmare River (facing page), which I had taken at 1,500 feet from the top of a mountain; I sent it off. The commission I received required photography of an island off the coast of County Kerry in southwest Ireland, providing me with my first helicopter flight, very exciting and a bit scary. The island was only ten minutes' flying time from the photograph which I had submitted. The client was pleased with the resultant photography, and my career had literally 'taken off'.

All of my aerial photography up to the end of the year 2000 was taken with a medium-format Hasselblad camera providing square compositions and using superb Carl Zeiss lenses. Within the period I had two books published and, looking back, they were very much at the end of the era of film. At that time, the first reasonably priced single lens reflex digital camera came on the market, having previously been extraordinarily expensive. My photography changed to digital overnight. I had been scanning and working with photographs in digital format for a number of years. Digital photography gave me more creative freedom and the ability to provide instant results in a world where everything was wanted yesterday. Also, the cost constraint associated with film no longer existed. This book is an end product of all of that.

In sunny weather, Ireland is one of the most beautiful places in the world. I have sometimes waited a whole summer for suitable weather and then been rewarded with a day from heaven in late August or September. I wouldn't want to have been in a rush!

This collection of photographs has been created to share with you the beauty of Ireland as it has unfolded and presented itself on various flights taken over the past eight years. It is not meant to represent every part of the island; it is quite simply here and there from the air.

The love of my life has accompanied me on many flights; Fie is a good photographer and the book contains a number of interesting photographs taken from the 'other side of the helicopter'. We hope you enjoy what you see and will be tempted to come and explore this beautiful island for yourself.

Kevin Dwyer
2010

Athlone to the Sea

To TRAVEL from here to there is to wander. What better place to start my wanderings than Athlone, the crossroads in the middle of Ireland.

The Millennium Rally of the Inland Waterways Association of Ireland in August 2000 provided a fine spectacle with over 100 boats and barges.

Further down the Shannon River I came across special weirs for salmon fishermen at Castleconnell, County Limerick.

Glenstal Abbey and School are in the same county, and it is my understanding that the rules of the order of St Benedict allow for the consumption of up to one litre of wine a day. What better place to head to with a religious vocation?

The countryside can look superb from the air especially when crops are ripening. The anger of nature can be seen with a river in flood. The Rock of Cashel as always looking superb.

The River Suir continues as the focus of attention on a frosty morning near the town of Carrick-on-Suir.

More countryside and a beautiful morning along the River Blackwater, leading to Youghal, County Cork, where the river enters the Celtic Sea.

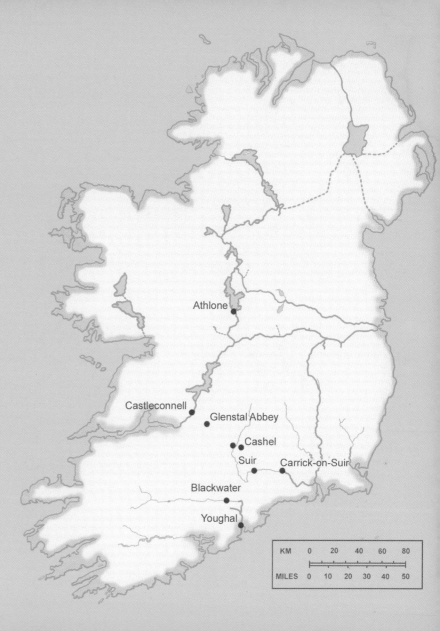

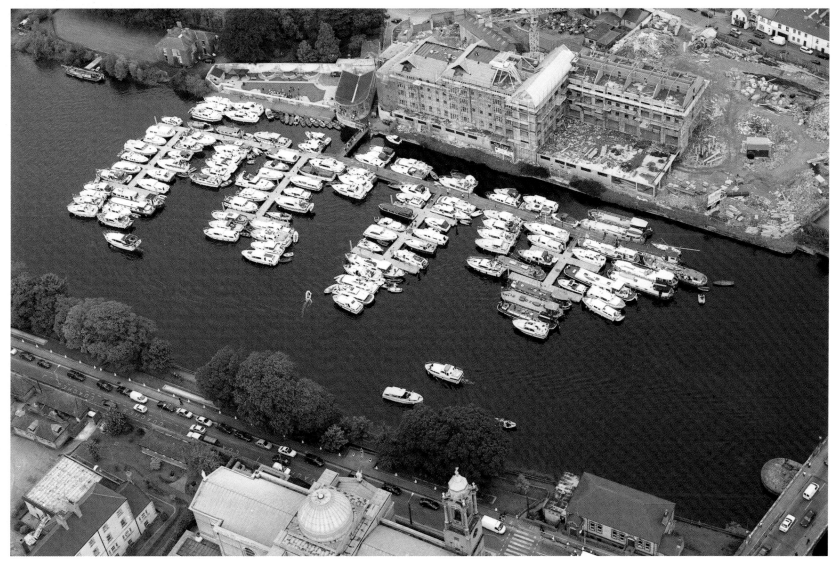

Over 100 boats and barges moored in Athlone, County Westmeath,
at the Inland Waterways Association of Ireland Millennium Rally, August 2000.

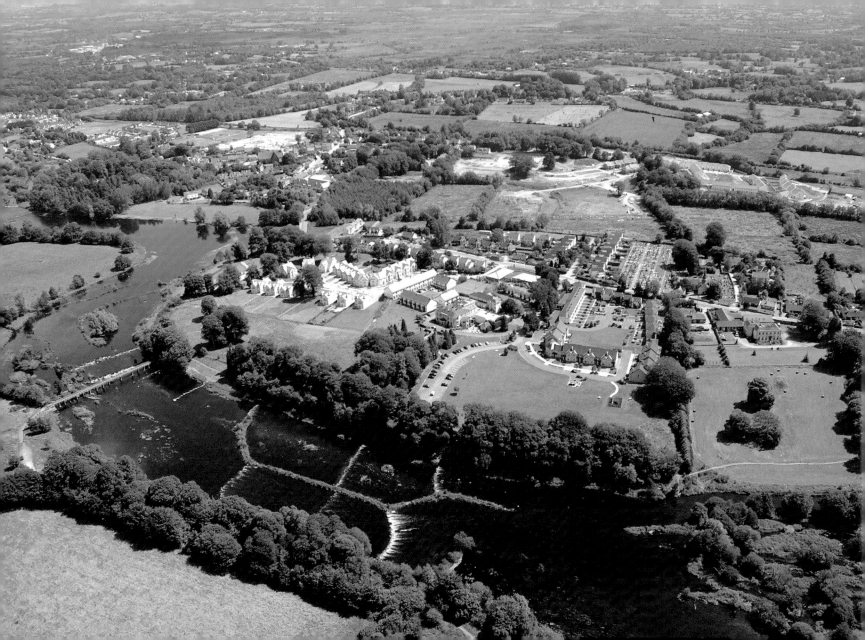

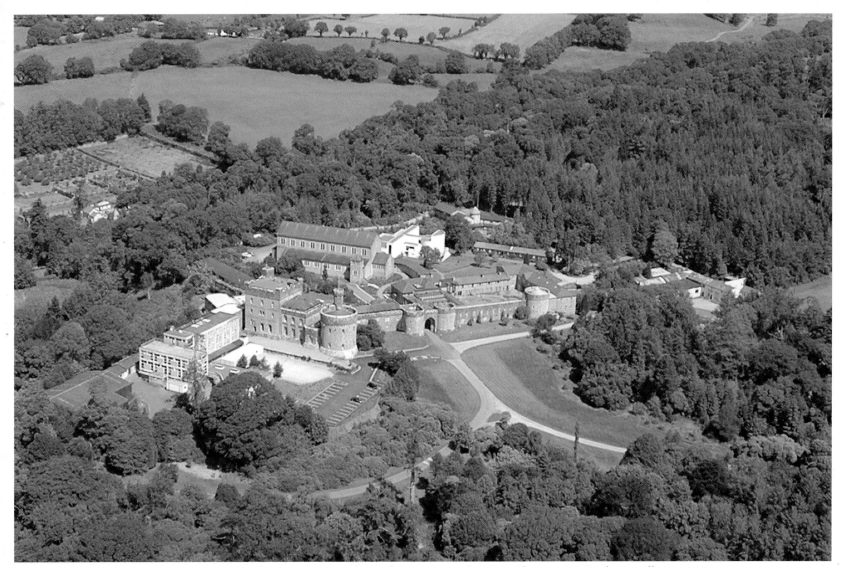

A man-made weir to assist salmon fishermen on the River Shannon at Castleconnell.
Above, Glenstal Abbey and School, Murroe, County Limerick, in all its magnificence.

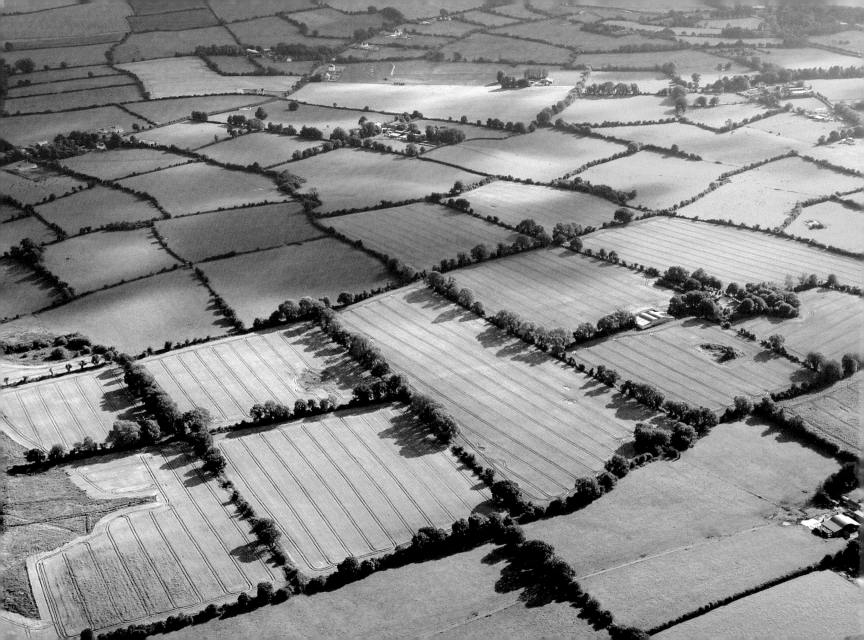

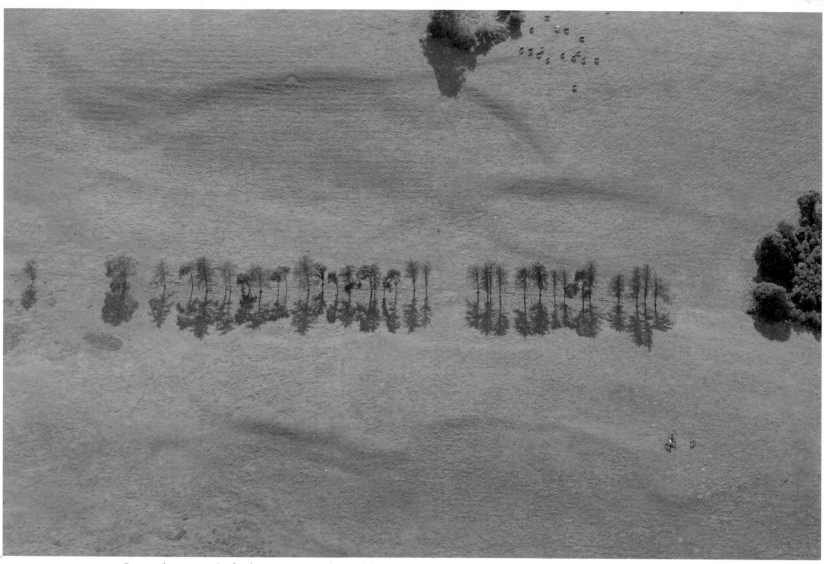

Crops almost ready for harvesting in the Golden Vale, and, *above*, a lonely row of trees in County Tipperary.

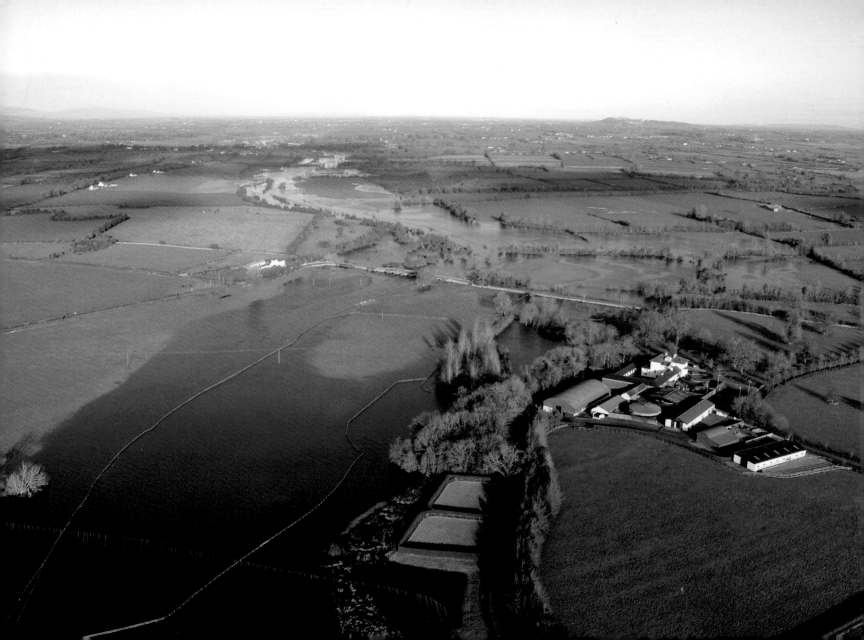

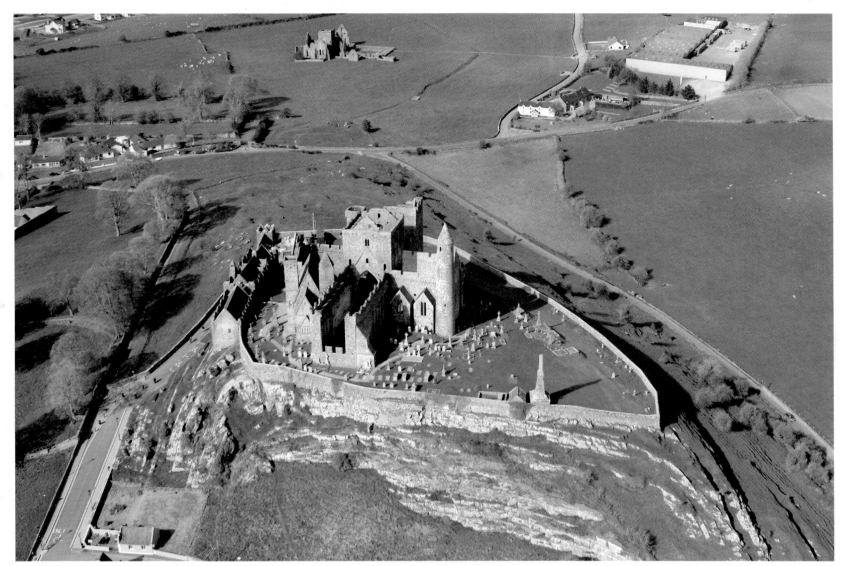

Winter flooding of the River Suir a few miles west of Cashel, County Tipperary.
Above, the Rock of Cashel, built in the thirteenth century.

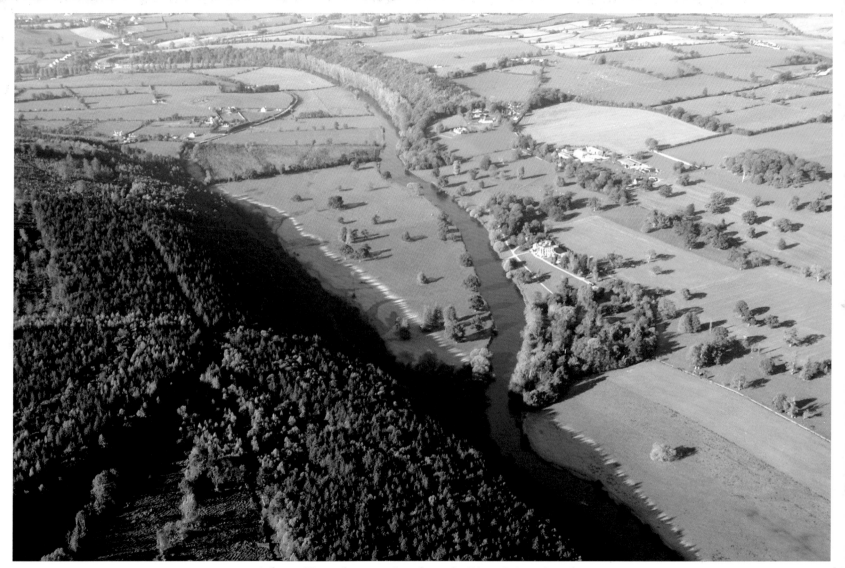

A frosty November morning along the River Suir and, *right*,
the town of Carrick-on-Suir in South Tipperary.

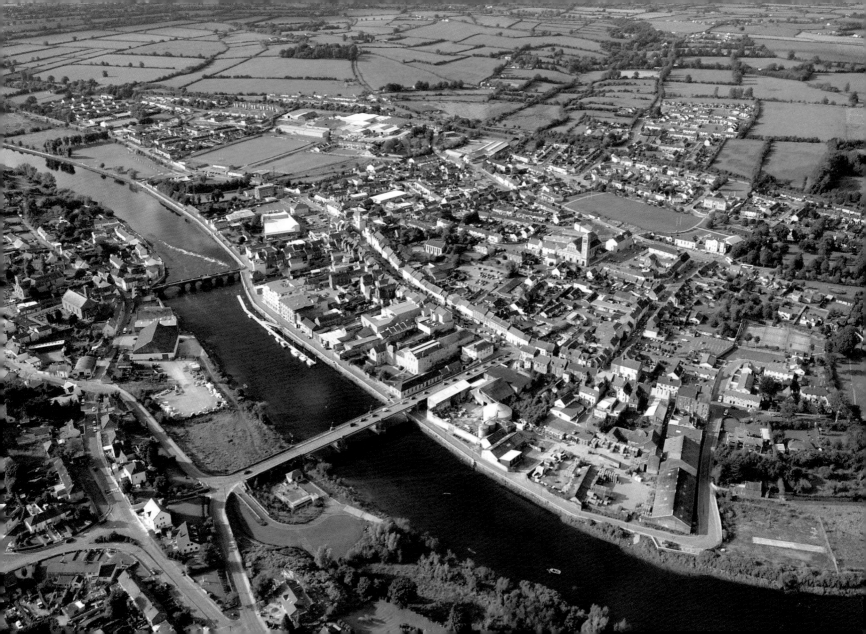

The startling sight of a field of oilseed rape in Tipperary and, *right*, early morning mist along the River Blackwater in County Cork (*photo* © *Fie Dwyer*).

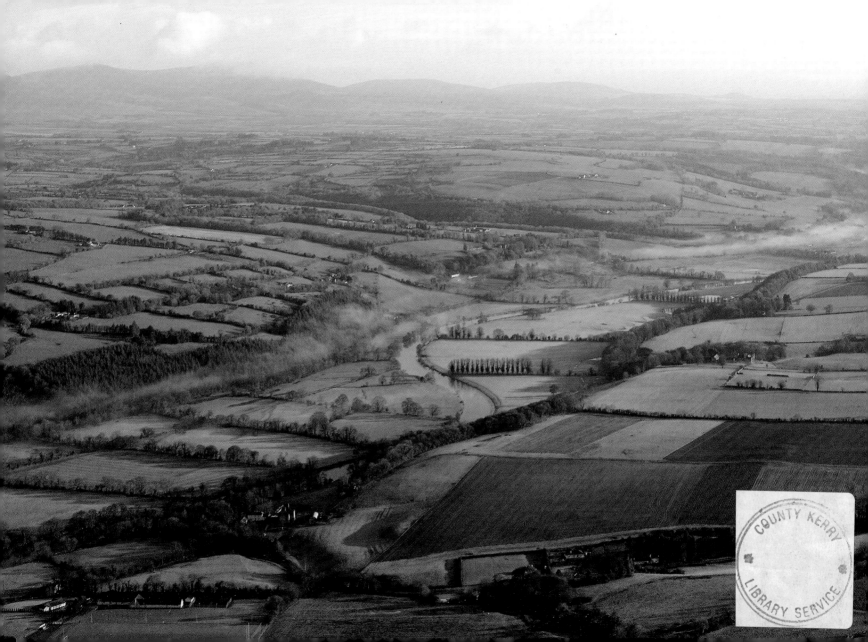

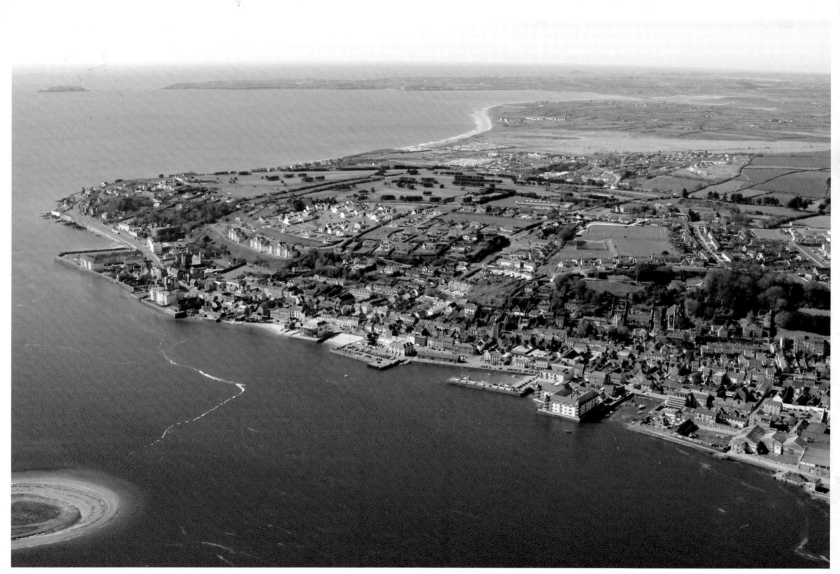

The River Blackwater entering the Celtic Sea at Youghal, County Cork.

The Rebel County

THERE IS a great feeling coming from County Cork and knowing that Cork city is the real capital of Ireland. I have always had a home in east Cork even though I spent ten years 'over the water', attending school, acquiring work experience and finding myself a wife.

Our home is near the village of Ballycotton from where these wanderings continue.

The great sailing heritage of the Royal Cork Yacht Club established in 1720 continues with 'Cork Week' taking place every second year and deemed to be the most fun sailing regatta in the world. I pass Roche's Point Lighthouse, Cobh, Fota Island, Cork city and then up to the source of the River Lee at Gougane Barra.

The town of Kinsale is ever beautiful, contrasting with the rugged nature of the Old Head of Kinsale nearby.

On an exceptionally beautiful day I pass over the bays of Courtmacsherry and Clonakilty, finding inlets, beaches, rocky coast and islands. There is a substantial contrast between orderly housing in the west Cork town of Skibbereen and a lonely cluster of houses beyond Allihies on the Beara Peninsula.

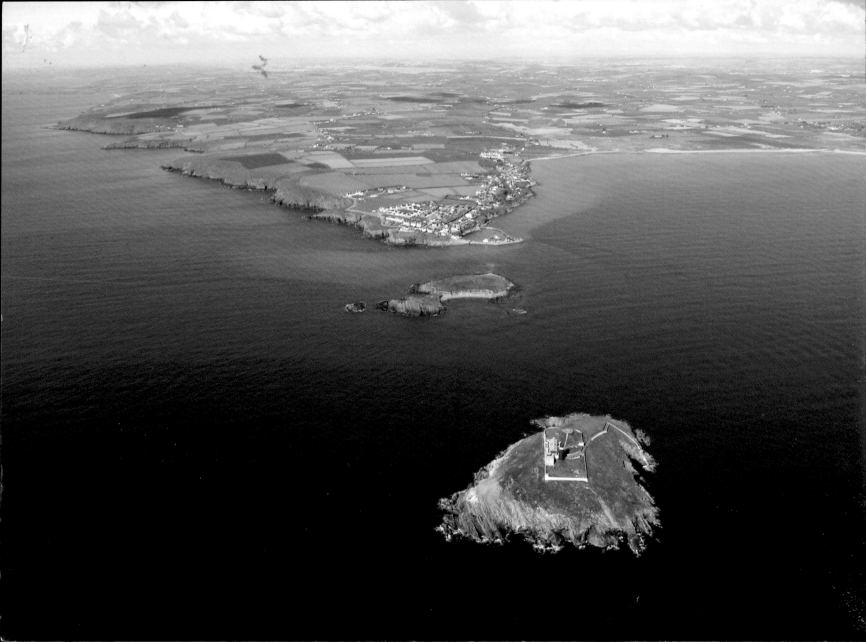

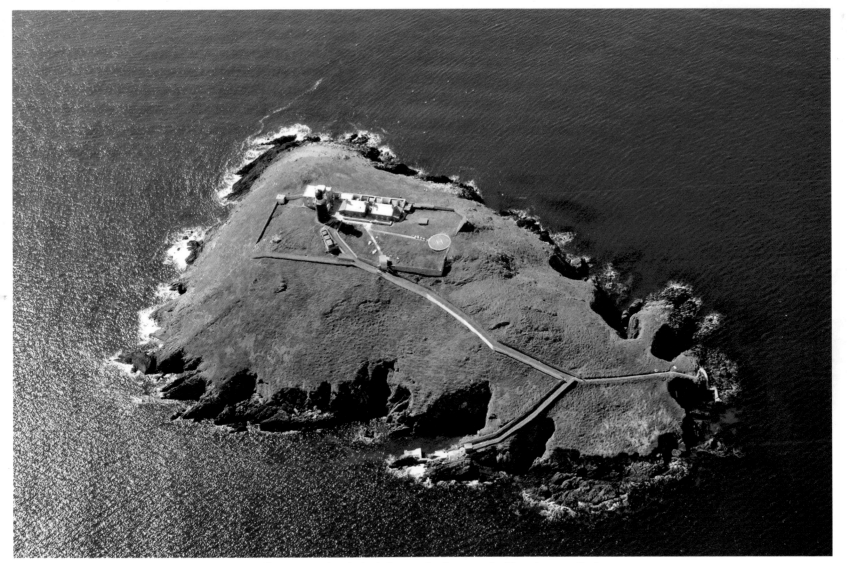

Ballycotton Island, Lighthouse, harbour and village in east Cork.

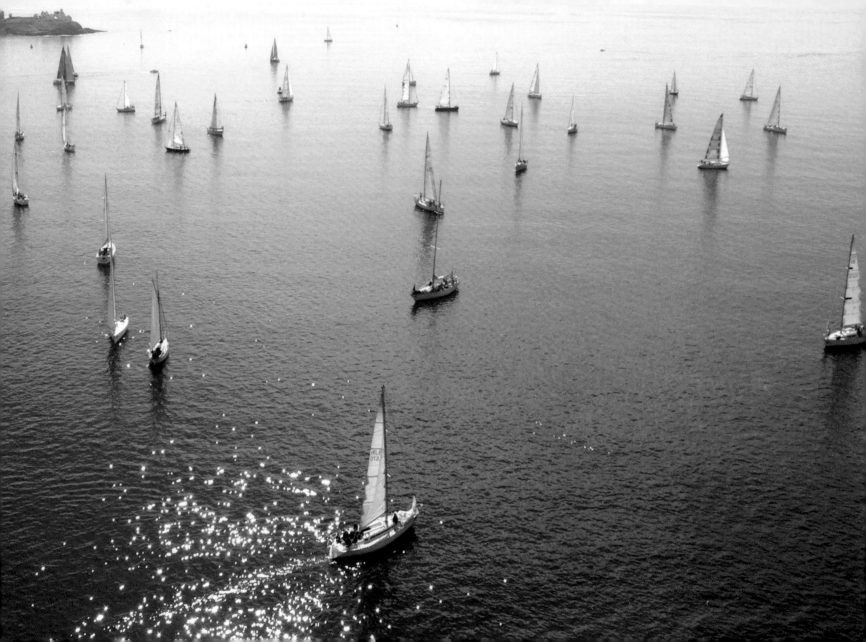

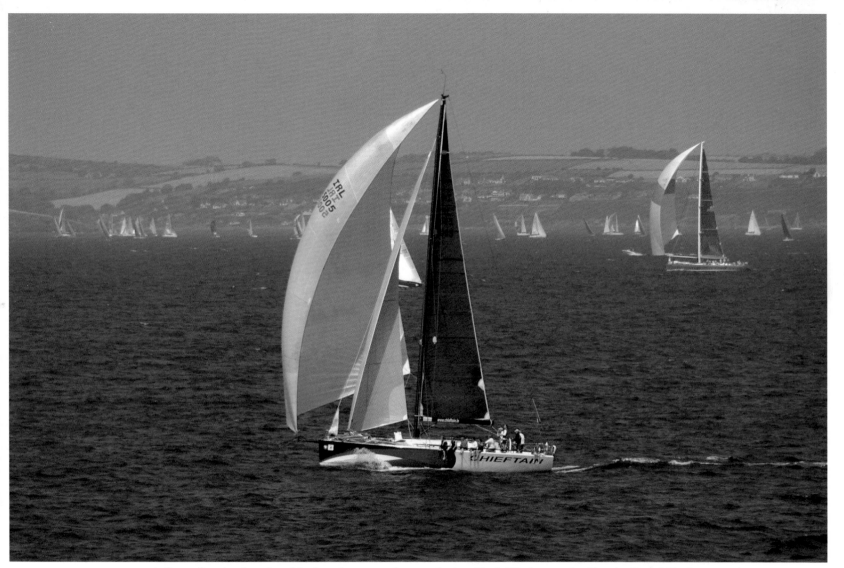

A fleet of yachts becalmed before the start of a race during Cork Week organised by the Royal Cork Yacht Club in 2006 and, *above*, the beauty and power of sail, captured during the regatta.

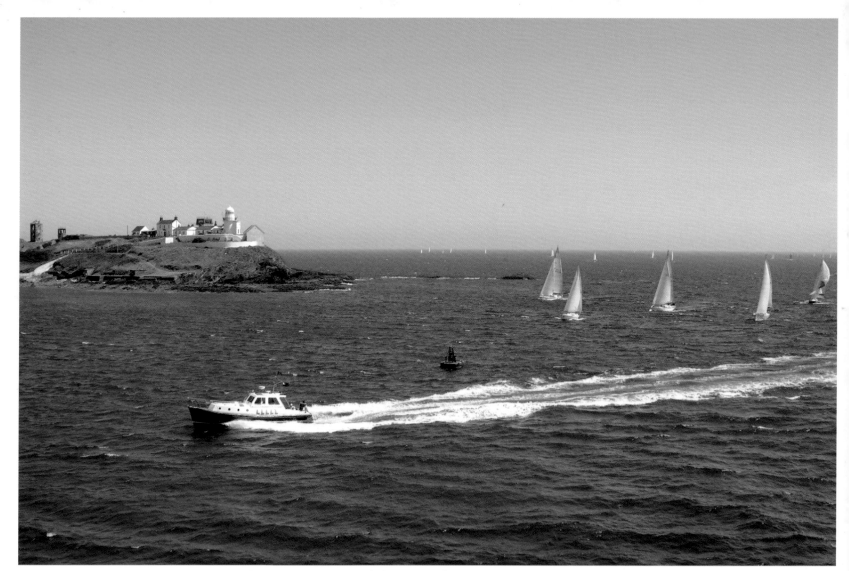

Great activity near Roche's Point at the entrance to Cork Harbour.
Right, colour and contrast in the town of Cobh, County Cork.

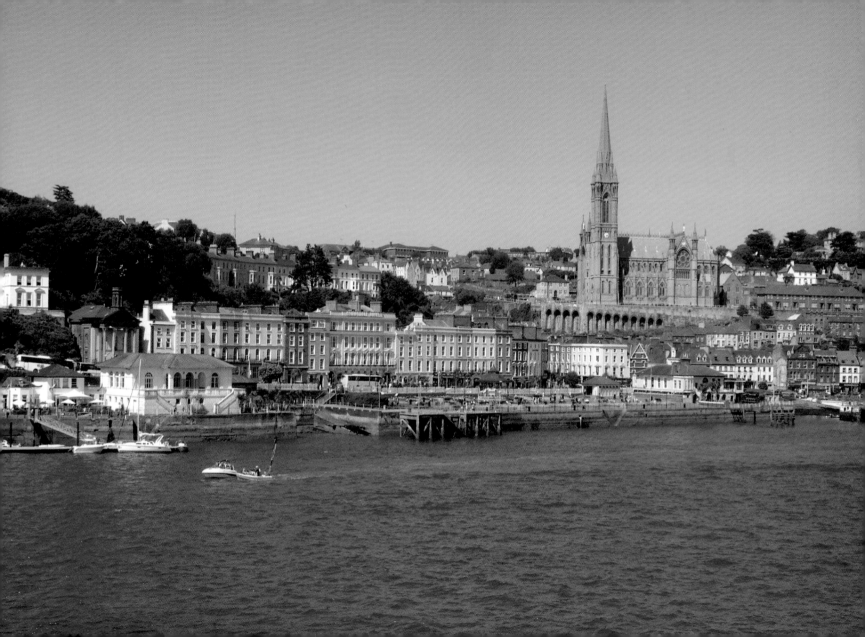

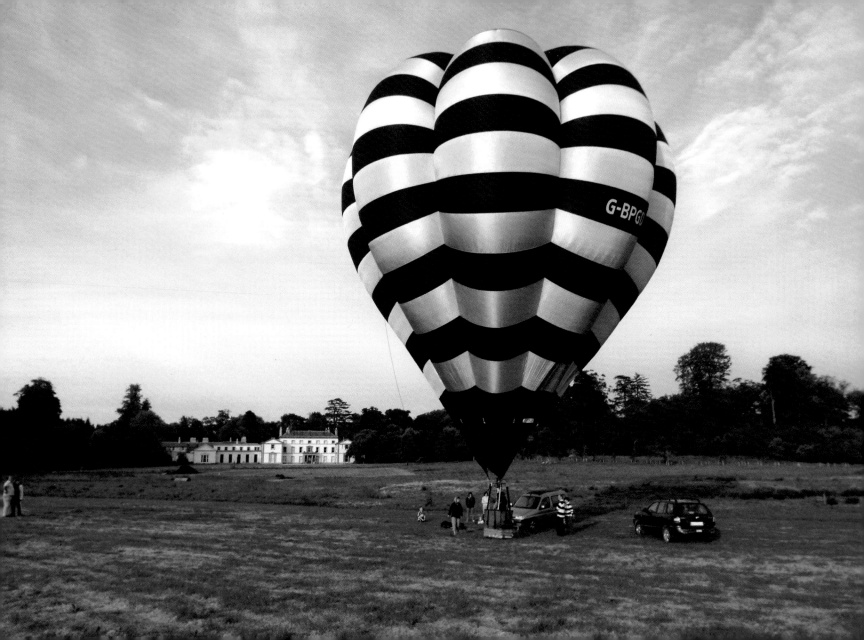

An air balloon in front of Fota House, County Cork, in May 2004, and later flying over Fota Island Golf Club.

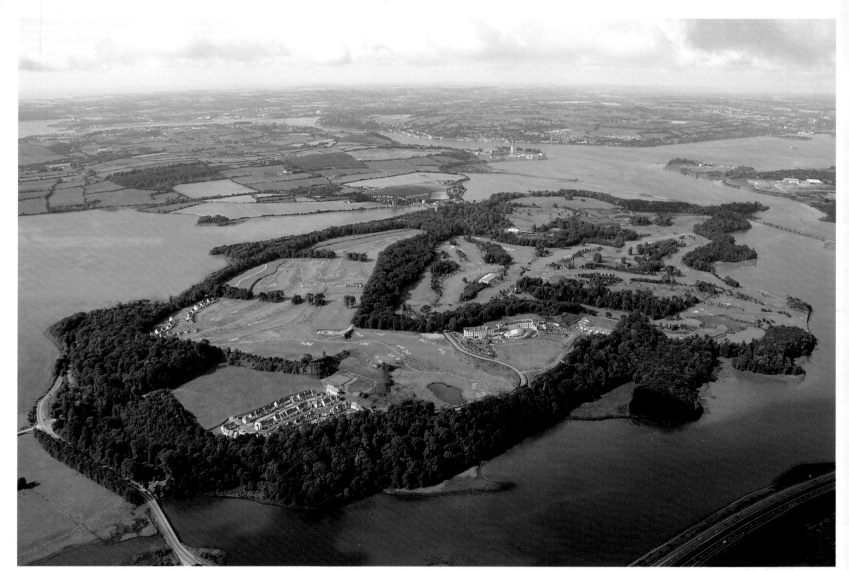

The Fota Island Resort, nestled in Cork Harbour and, *right*, The Marina, Atlantic Pond, Páirc Uí Chaoimh, and Showground near the docklands, Cork city.

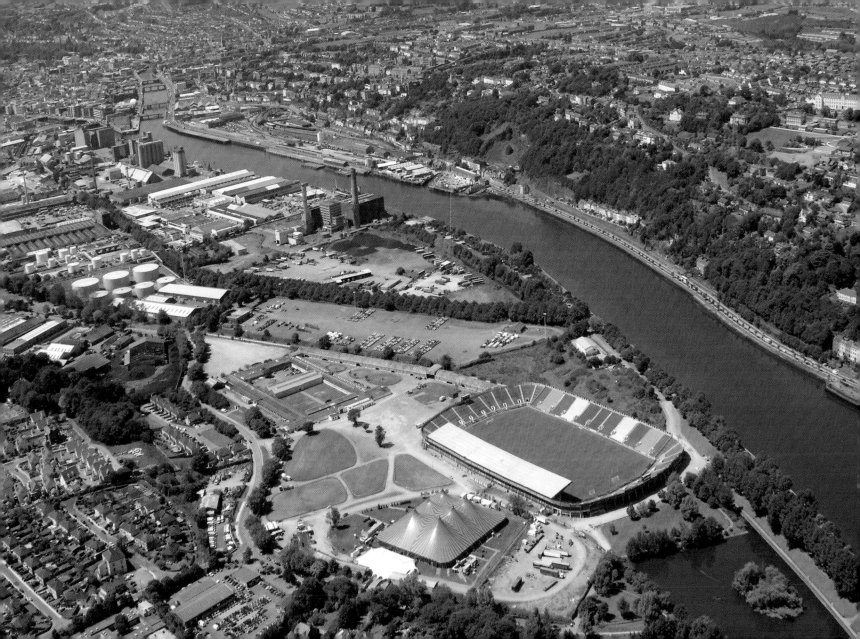

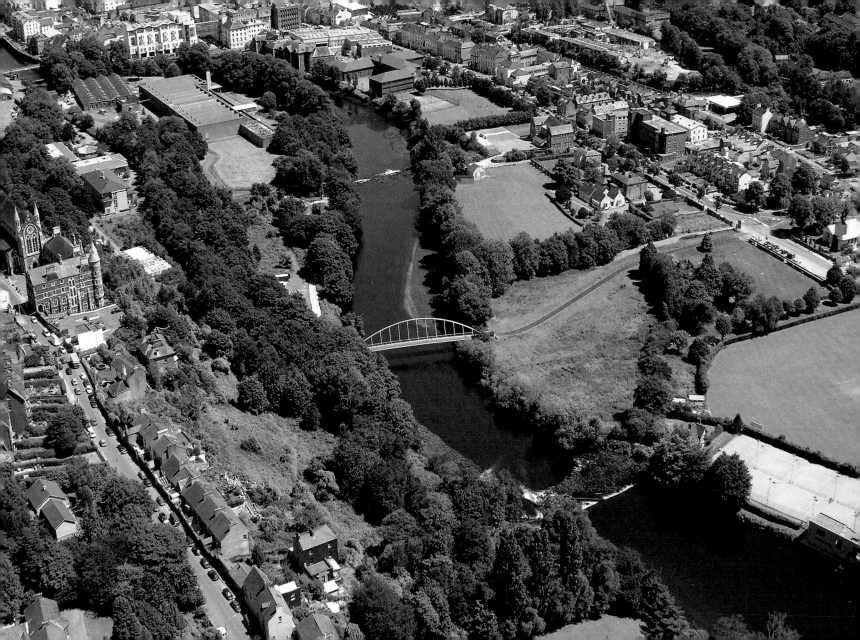

Sunday's Well to the left, overlooking the Mardyke with its new pedestrian bridge and riverside walkway.
Above, Cork City Gaol Heritage Centre in Sunday's Well. The Gaol operated from 1824 to 1923.

The lakes of the River Lee Hydro-Electric Scheme above Carrigadrohid Dam near Macroom. *Right*, the source of the River Lee at Gougane Barra, County Cork. Bantry Bay is just visible in the top left corner.

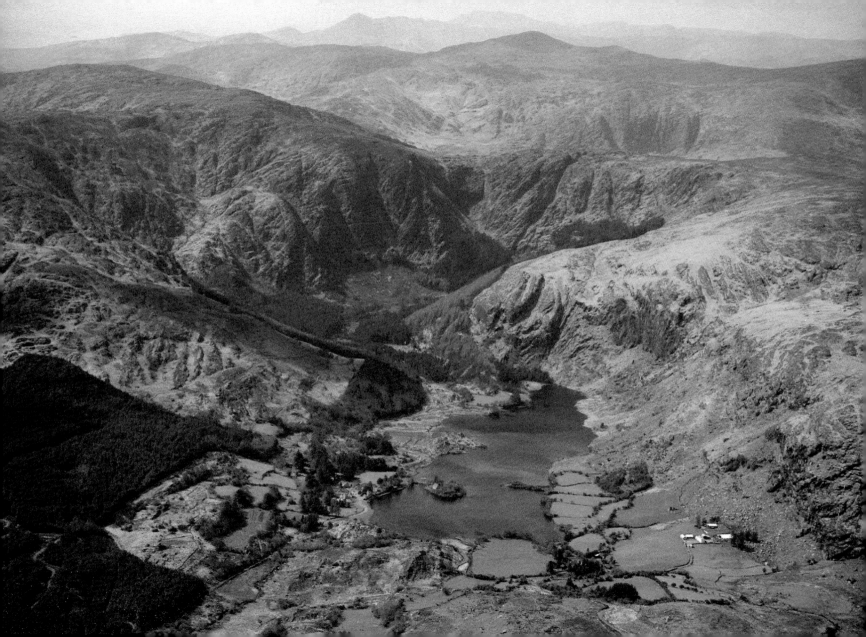

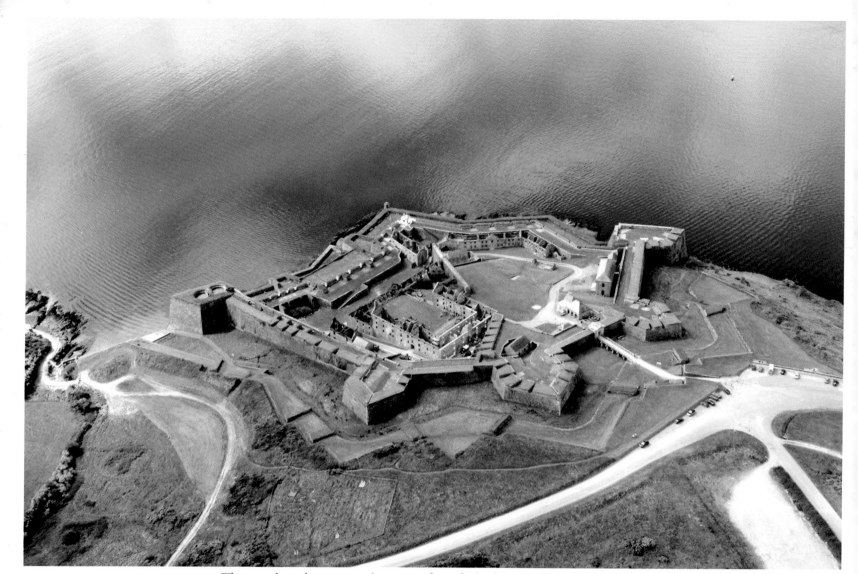

The star-shaped, seventeenth-century fort of Charles Fort, Kinsale and, *right*,
Scilly, County Cork, and the Kinsale Yacht Club marina.

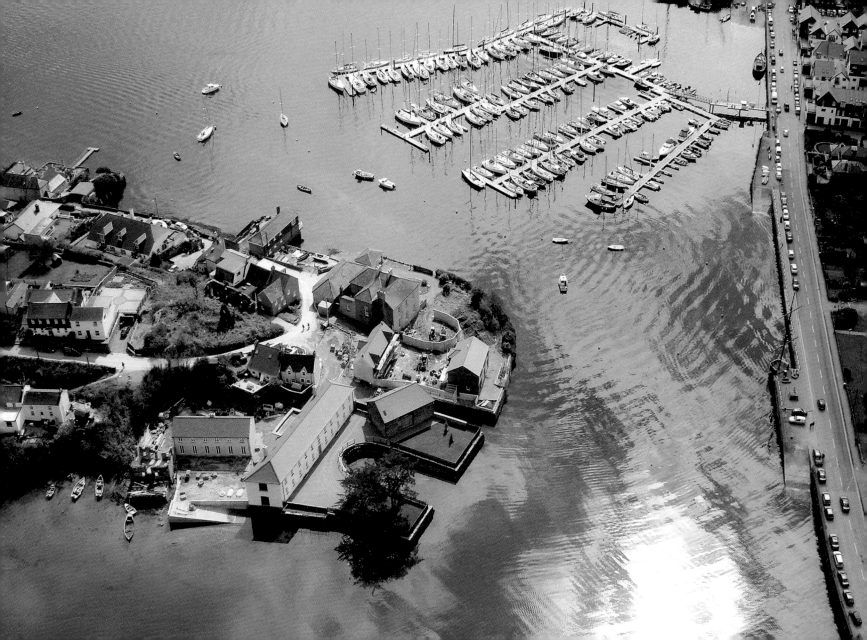

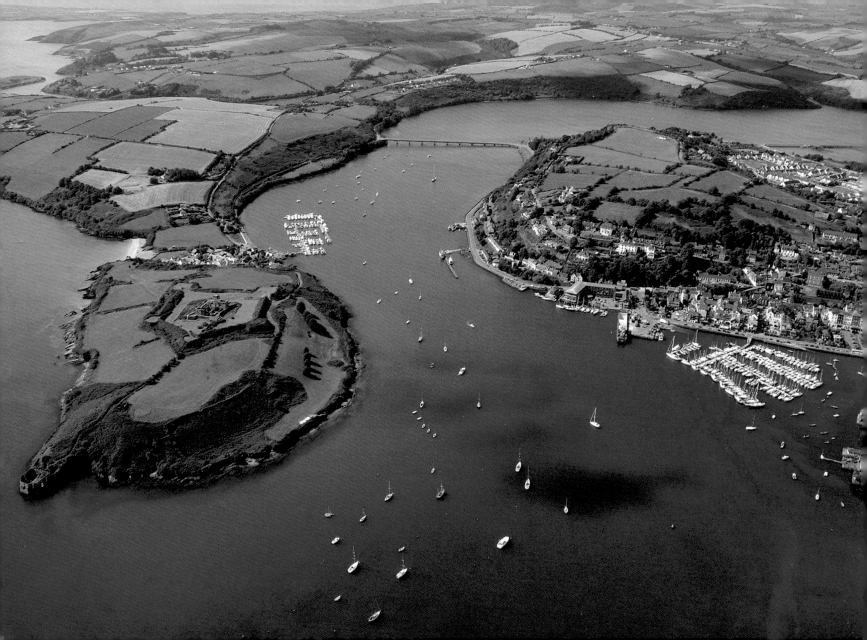

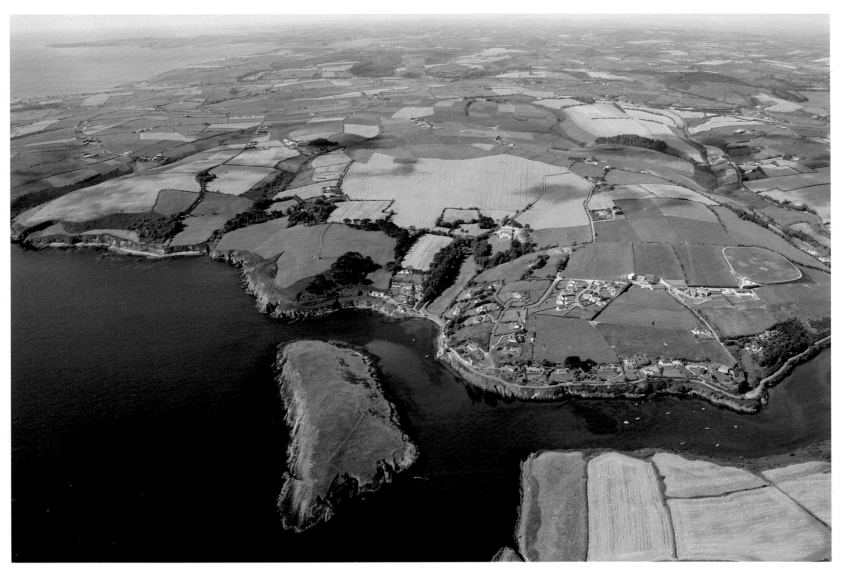

James's Fort on a commanding position, overlooking Kinsale.
Above, Sandycove and Island, near the entrance to Kinsale harbour.

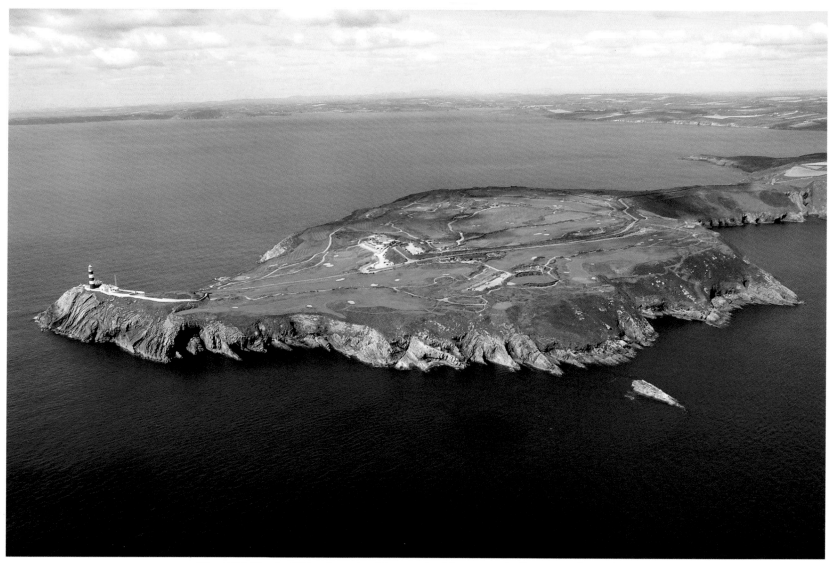

The Old Head of Kinsale and golf course looking towards Courtmacsherry Bay and, *right*, the lighthouse perched on The Old Head of Kinsale, County Cork.

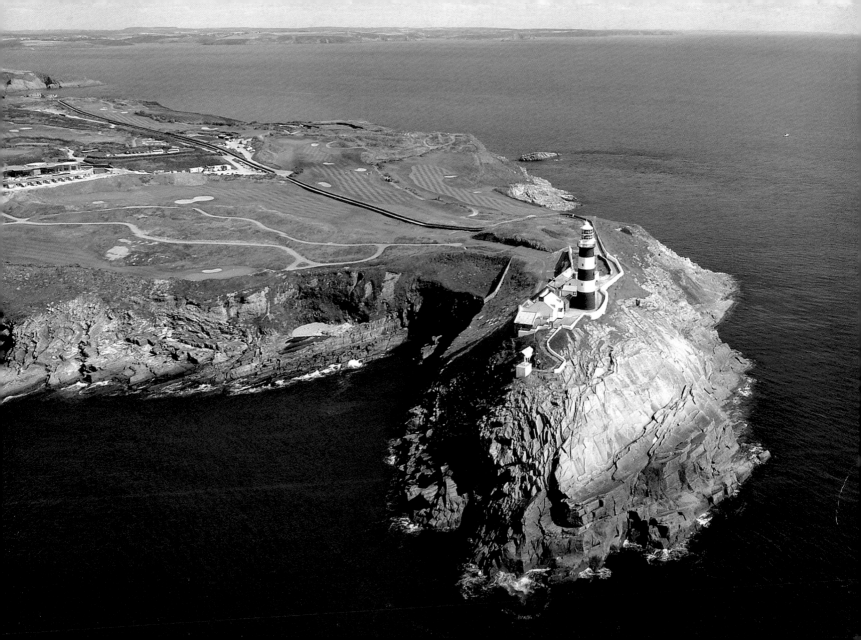

The lifeboat and west Cork village of Courtmacsherry.
Right, Broadstrand Bay near Courtmacsherry, County Cork.

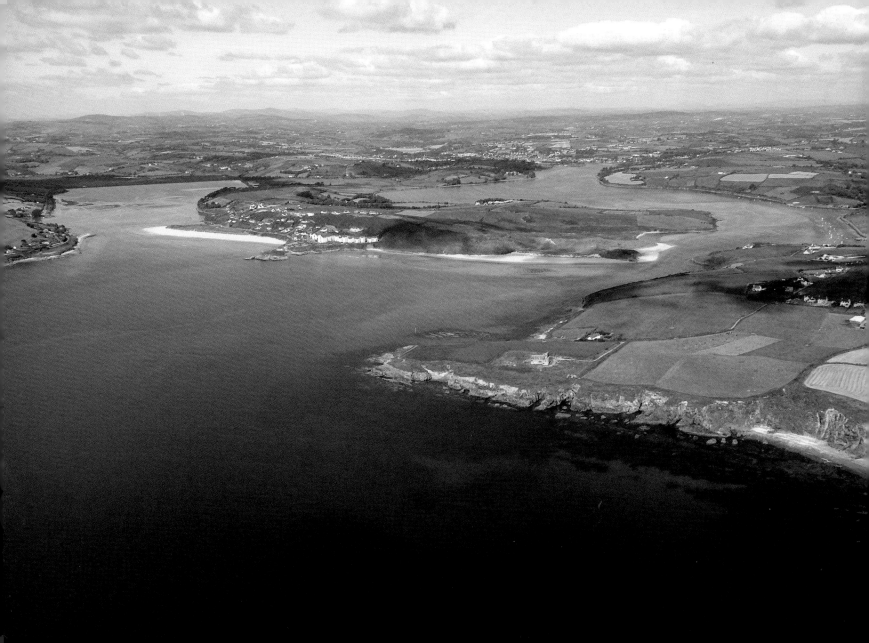

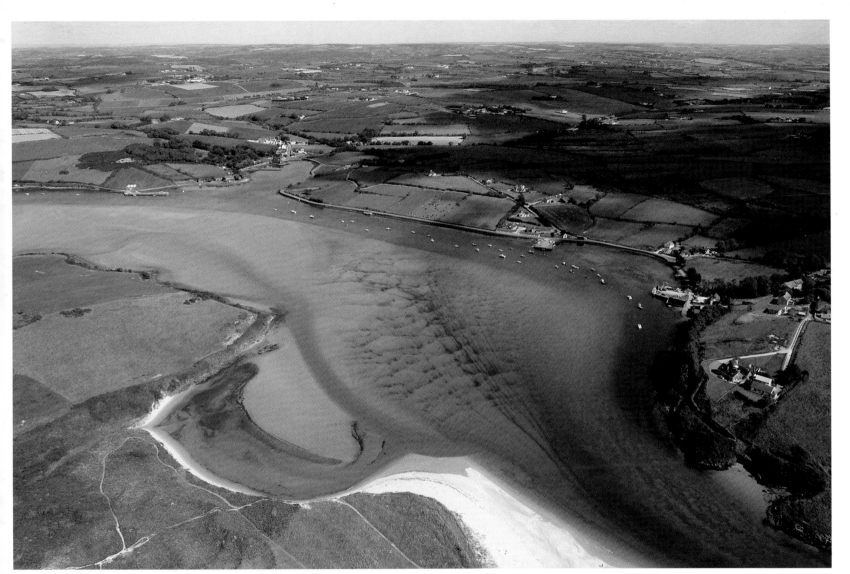

The beaches of Inchydoney in Clonakilty Bay. *Above*, the quay
at Ring at the entrance to Clonakilty harbour.

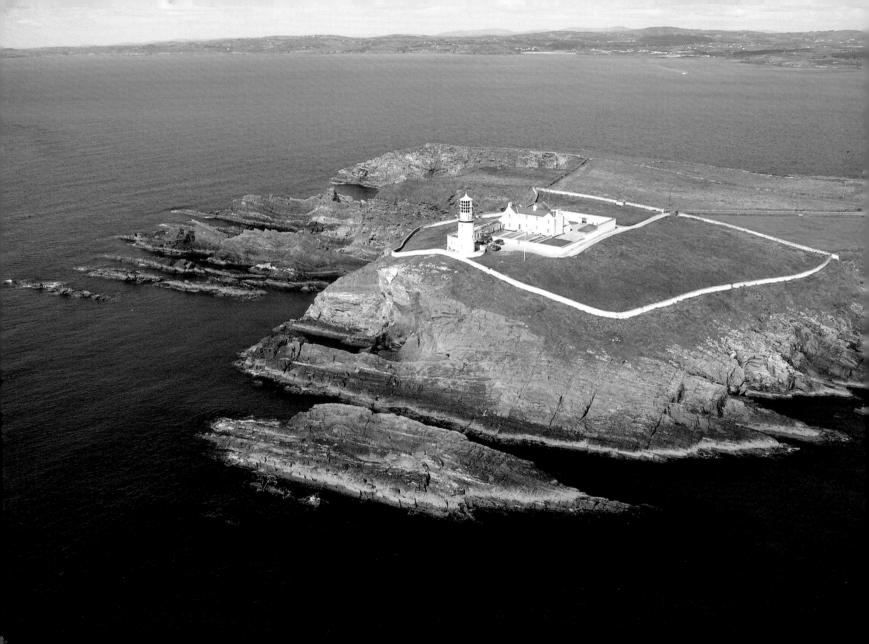

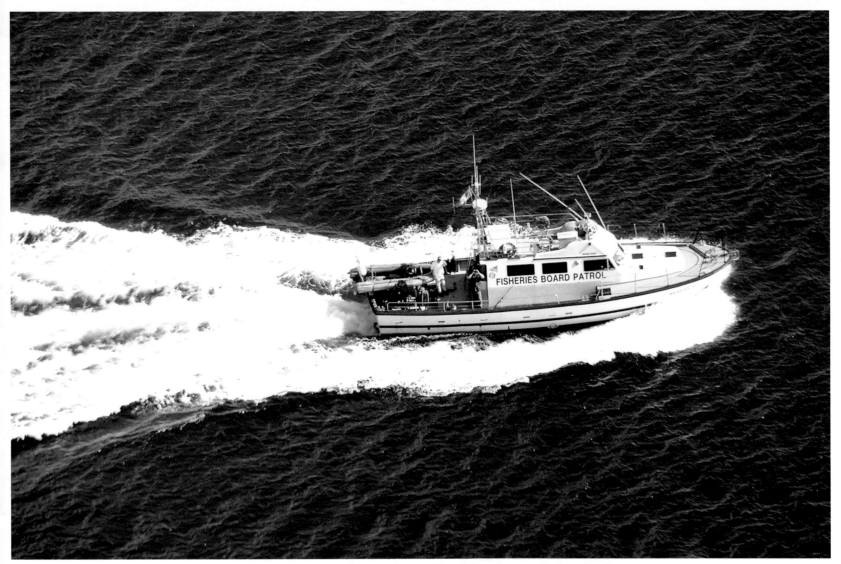

The lighthouse at Galley Head near Clonakilty, County Cork and, *above*,
looking at them, looking at us: a Fisheries Board Patrol in Rosscarbery Bay.

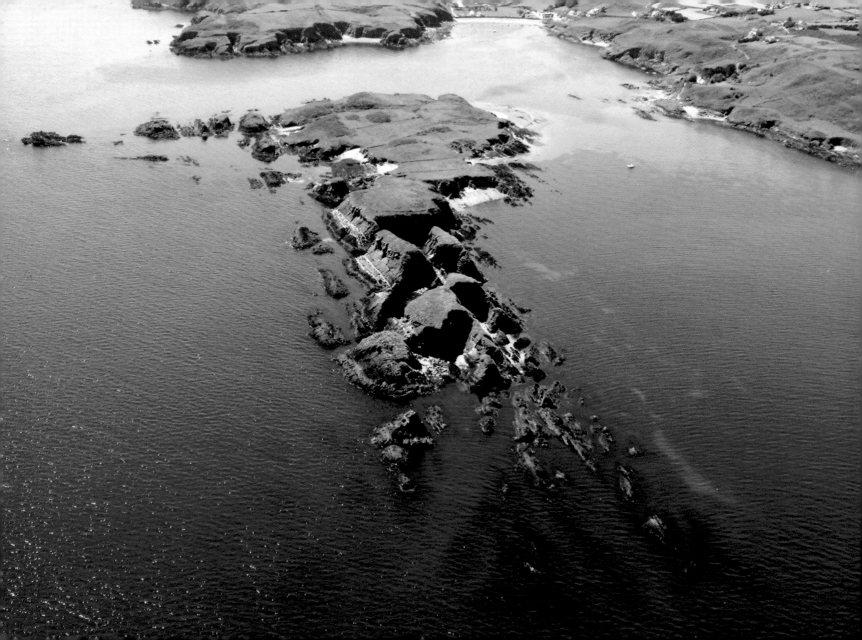

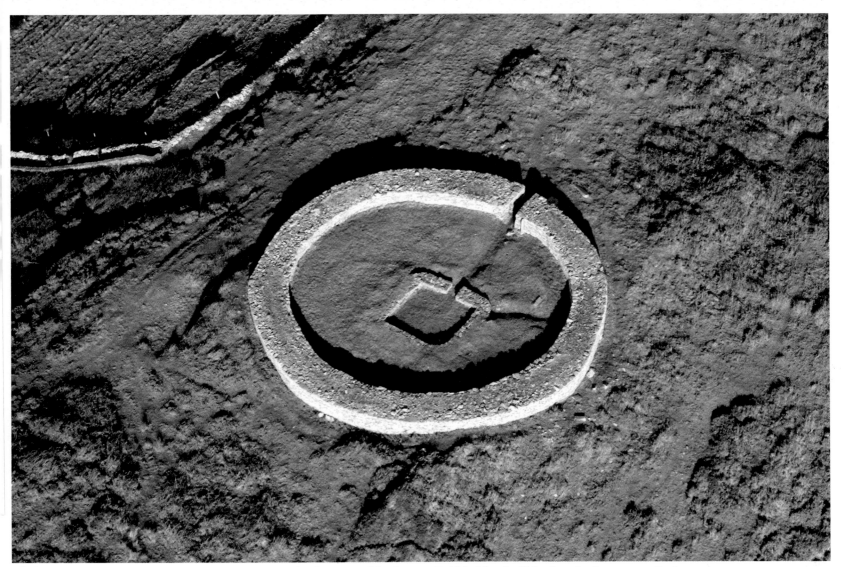

The Stack of Beans in the foreground leading to Rabbit Island off Squince harbour, west Cork.
Above, Ring Fort at Knoc Dromha overlooking Castlehaven, County Cork.

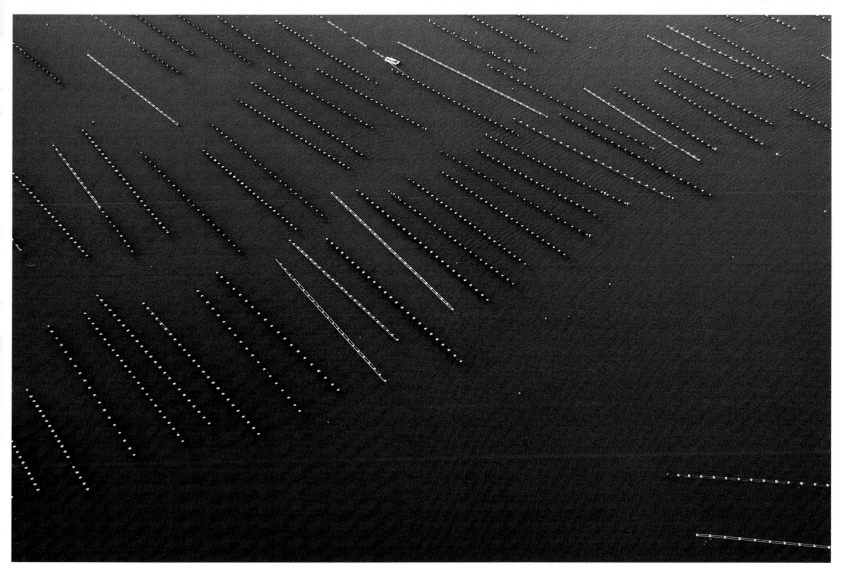

Awash with wake in Roaringwater Bay. *Above*, mussel rafts in Bantry Bay (*photos © Fie Dwyer*).

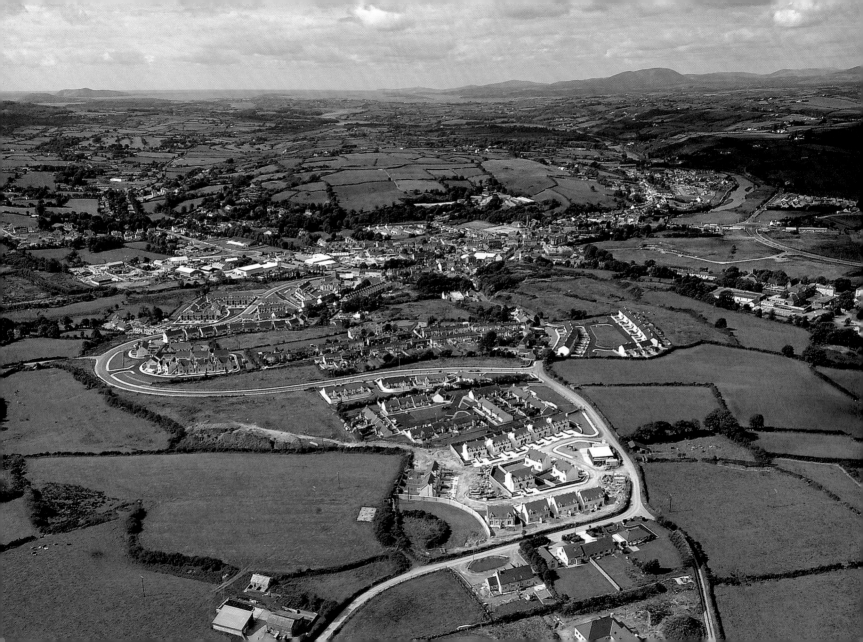

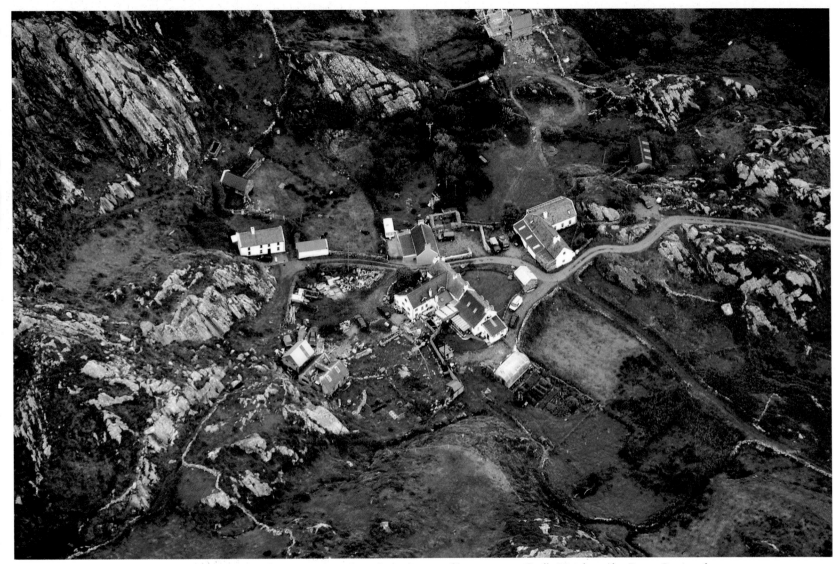

Skibbereen, the capital of west Cork and, *right*, a cluster of houses near Cod's Head on the Beara Peninsula.

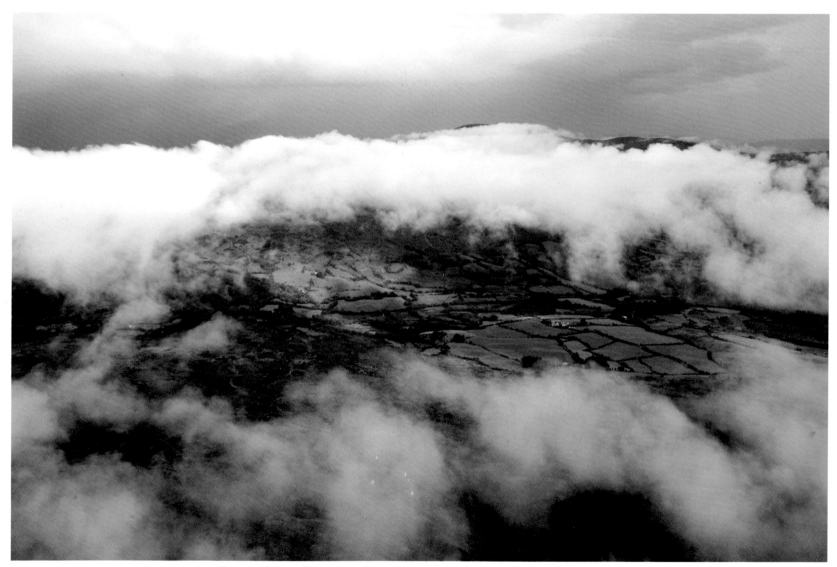

Changeable weather, somewhere over west Cork, providing a heavenly view.

The Kingdom of Kerry

FOR FORTY YEARS of my life, twenty-five of my wife's and up to the end of the teenage years of our children, family holidays were spent at Derrynane in southwest Kerry.

There were beautiful beaches and there was a lot to do: swimming, cycling, and hill walking. There was song, laughter and a drink or two. Lifelong friendships were made; there was occasional sunshine and plenty of rain! But we loved it. Kerry has a magic of its own.

My wanderings start above Ladies View, Killarney. I have spent countless times jumping around rocks like a goat, trying to find the perfect photographic position. A bird's eye view is the only one that really works.

I head for the town of Kenmare, along the Kenmare River past the village of Sneem and where else but to Derrynane.

The Skellig Islands are majestic, and on Valentia Island remnants of an EIRE sign alerting passing airmen to neutral Ireland during the Second World War can just be seen.

Across Dingle Bay I see the Blasket Islands before slipping over the Conor Pass to Tralee Bay, the Magharee Islands and finally the popular seaside resort of Ballybunnion.

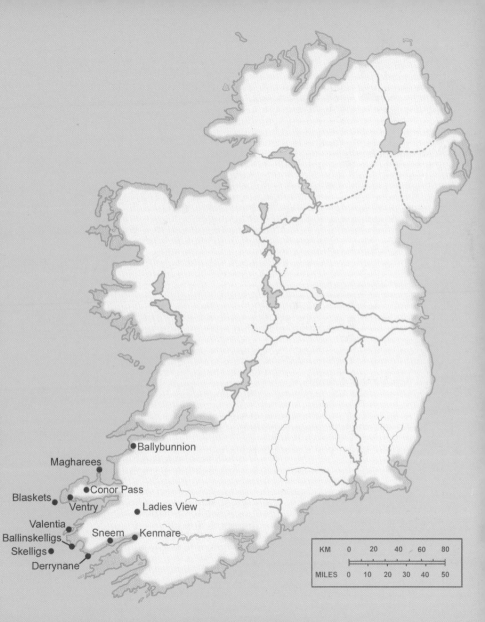

Right, autumn colours and the Lakes of Killarney from high above Ladies View.

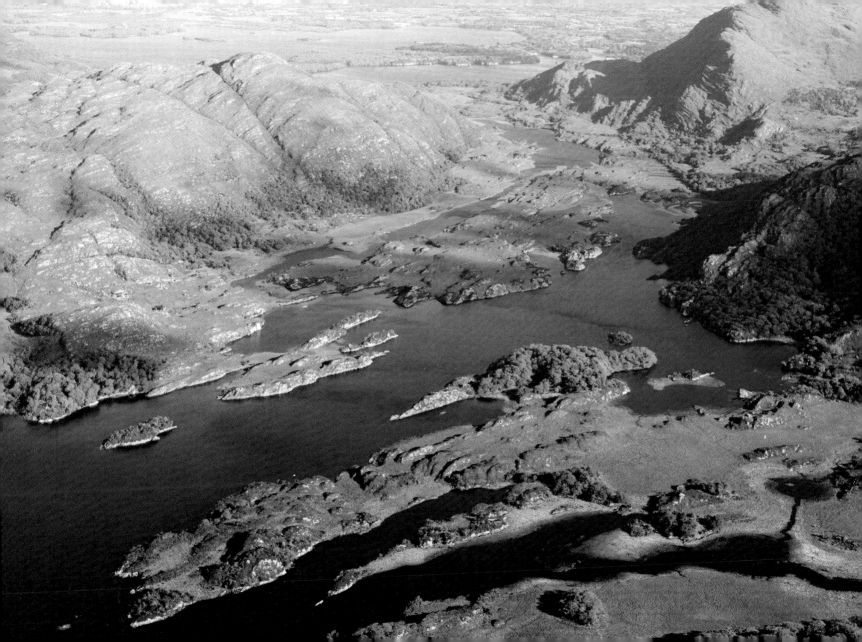

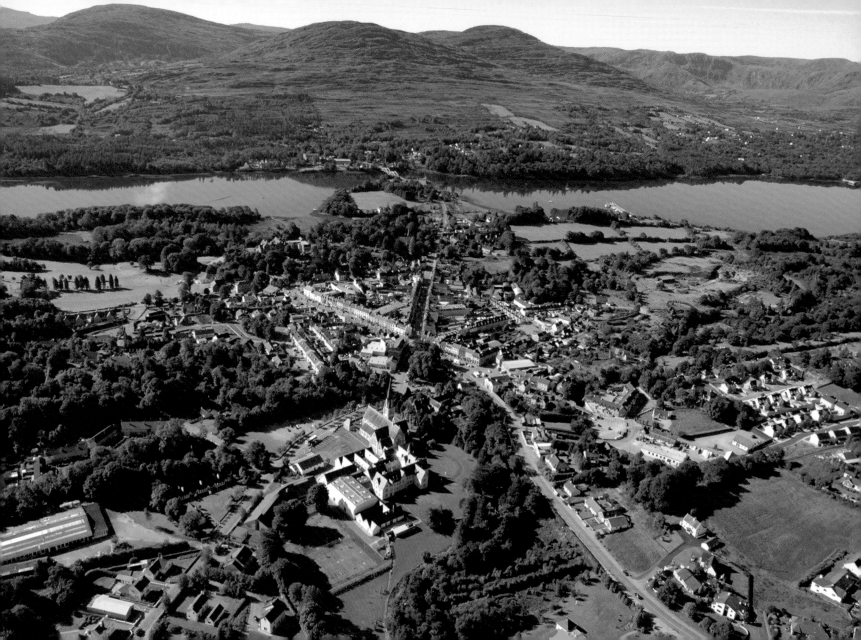

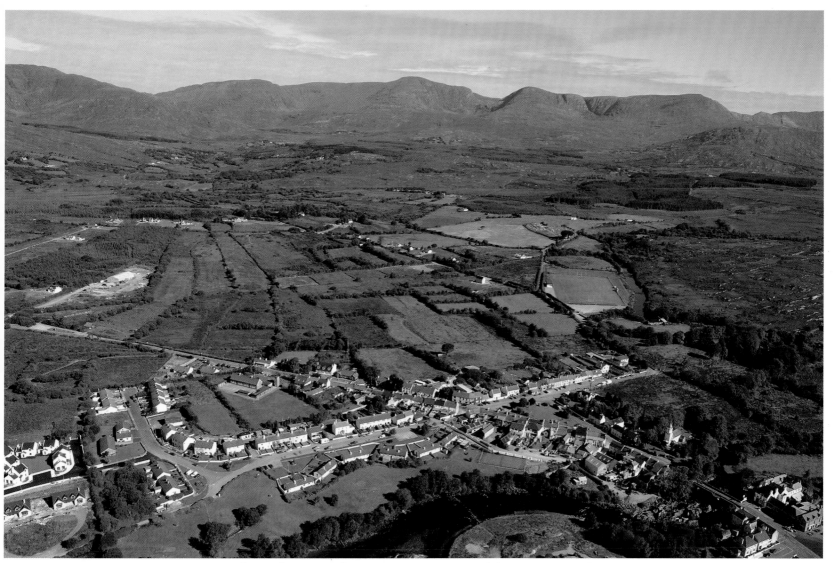

The market town of Kenmare, County Kerry (*photo © Fie Dwyer*).
Above, the village of Sneem with a beautiful mountain backdrop.

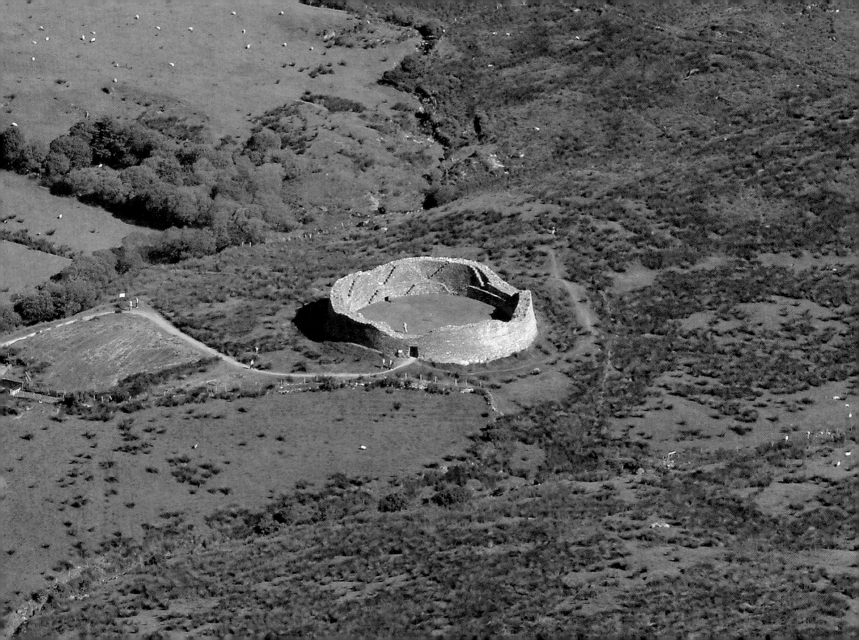

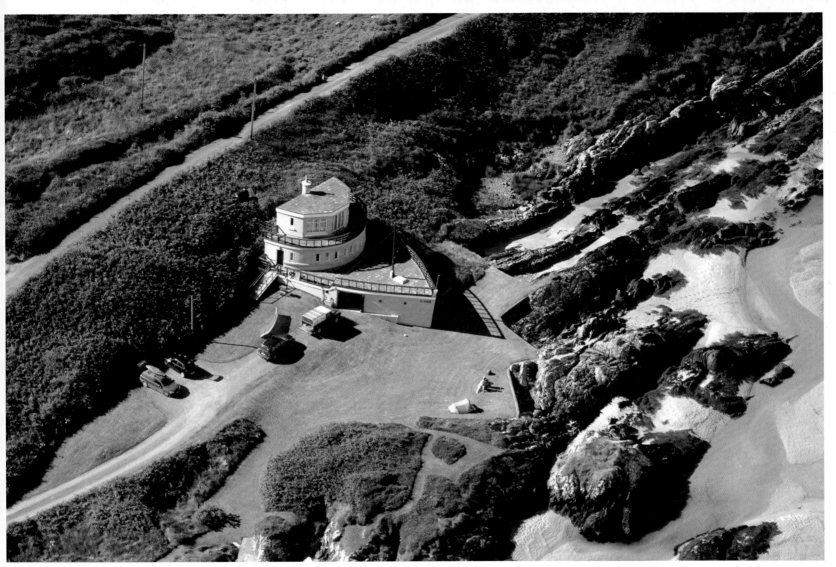

Staigue Stone Fort on the Ring of Kerry, built in the early centuries AD and, *above*,
The Ship House, Derrynane, County Kerry, built in the early 1950s (*photo © Fie Dwyer*).

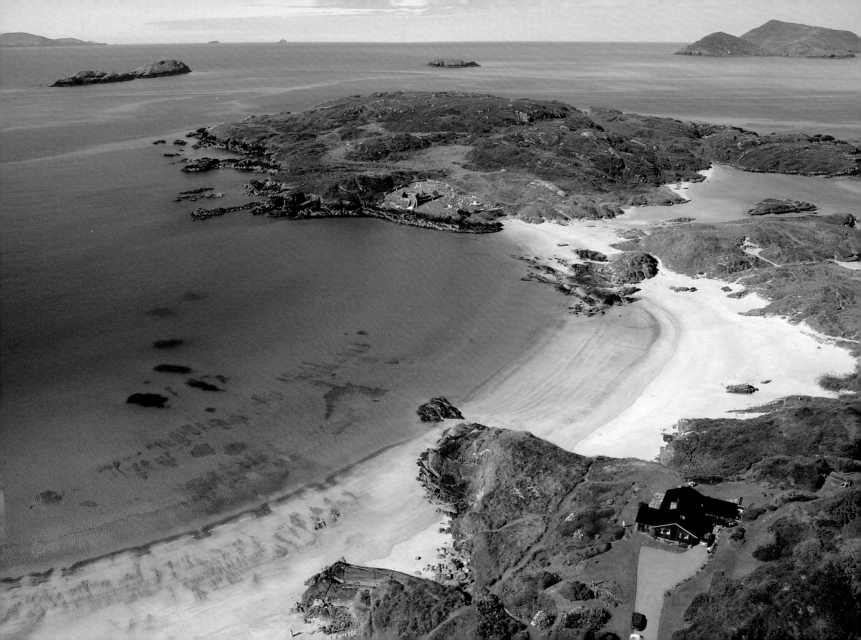

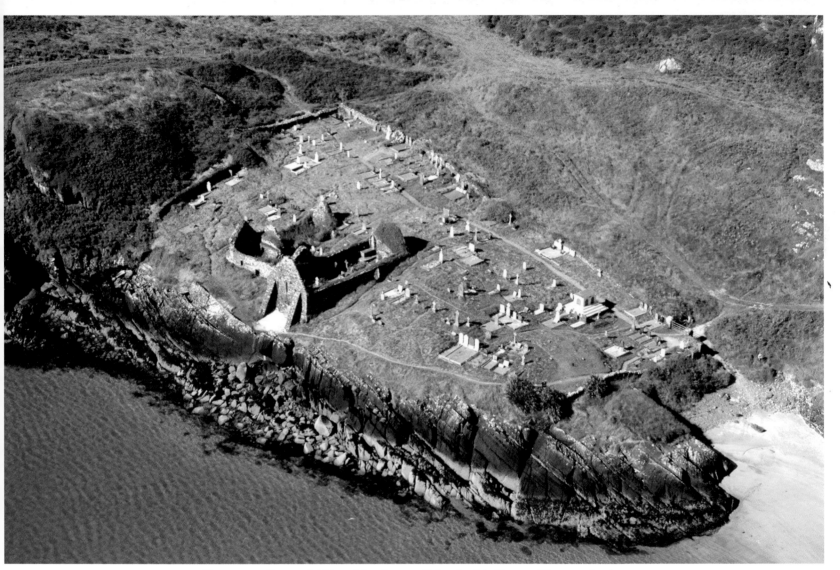

Derrynane Bay and Abbey Island, near Caherdaniel, County Kerry and, *above*,
the abbey and graveyard on Abbey Island, Derrynane (*photo © Fie Dwyer*).

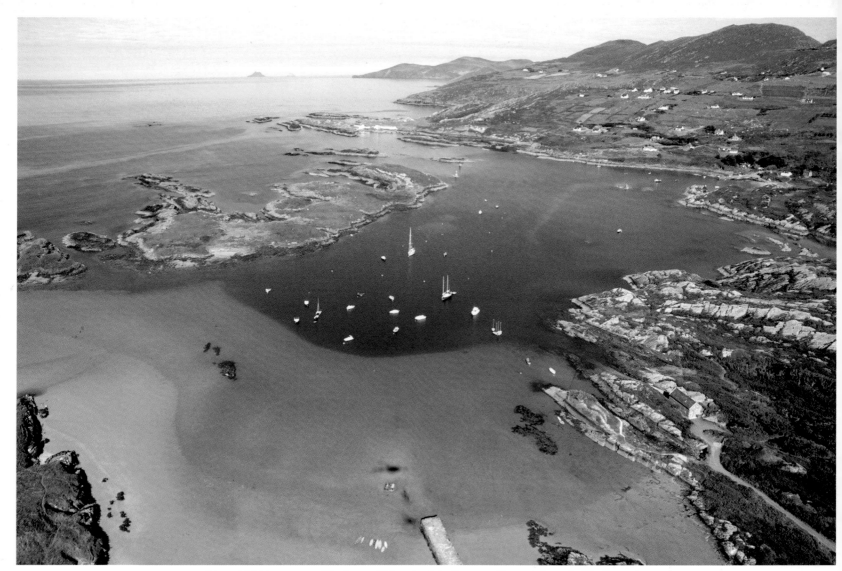

Beautiful Derrynane Harbour, Caherdaniel, County Kerry (*photo © Fie Dwyer*).
Right, an October sunset as seen from Derrynane with the Skellig Islands on the horizon.

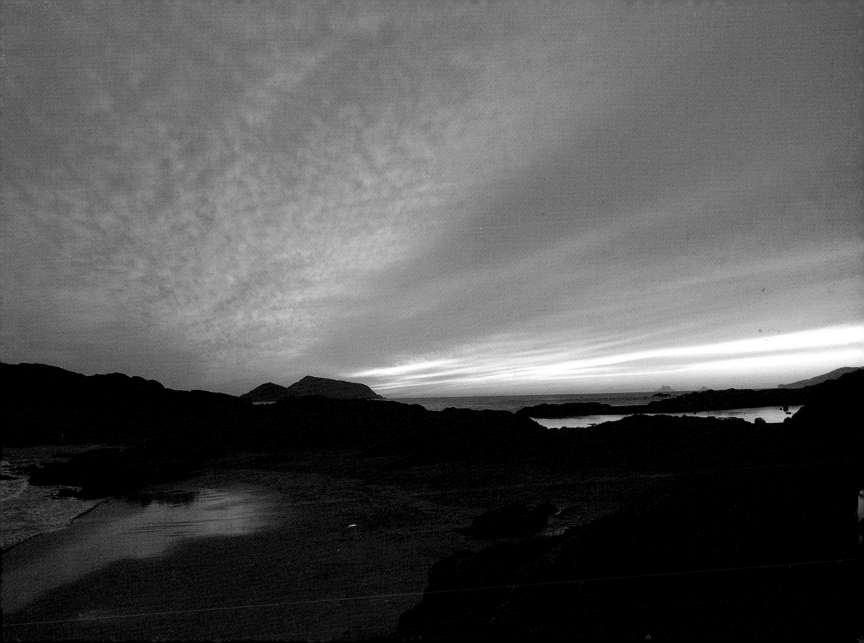

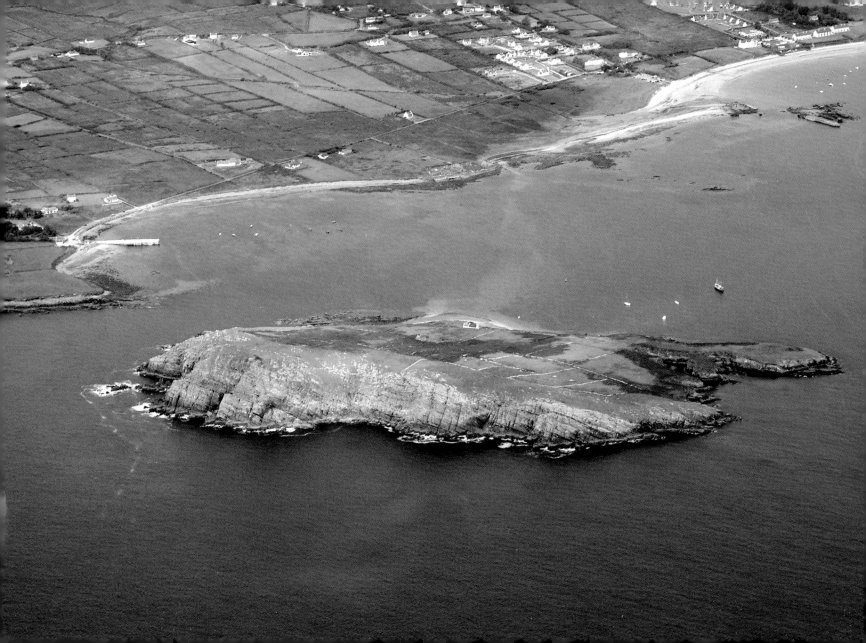

Horse Island providing shelter in Ballinskelligs Bay, County Kerry, and, *above*,
a patchwork of fields near Bolus Head, Ballinskelligs, County Kerry.

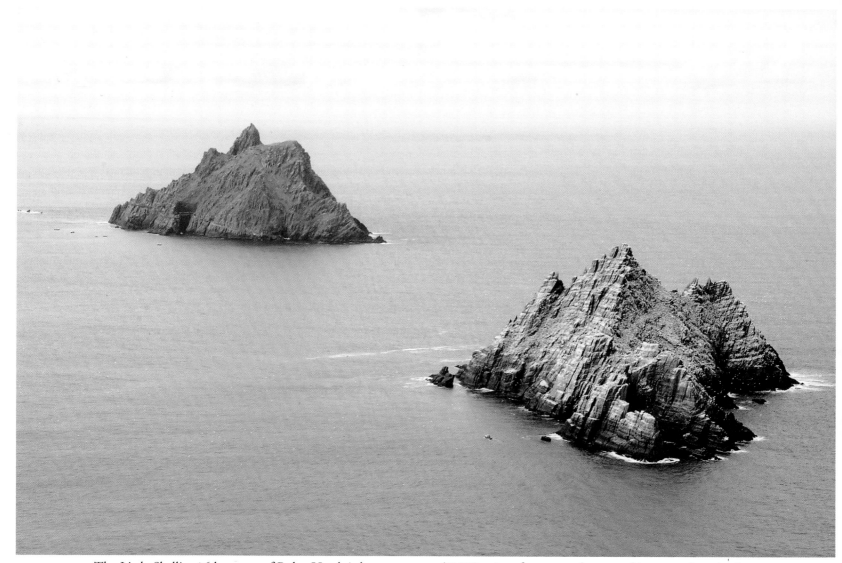

The Little Skellig, 16 km west of Bolus Head, is home to some 27,000 pairs of gannets, the second largest colony in the world. *Right*, boats waiting to return tourists home from the World Heritage Site of Skellig Michael, County Kerry.

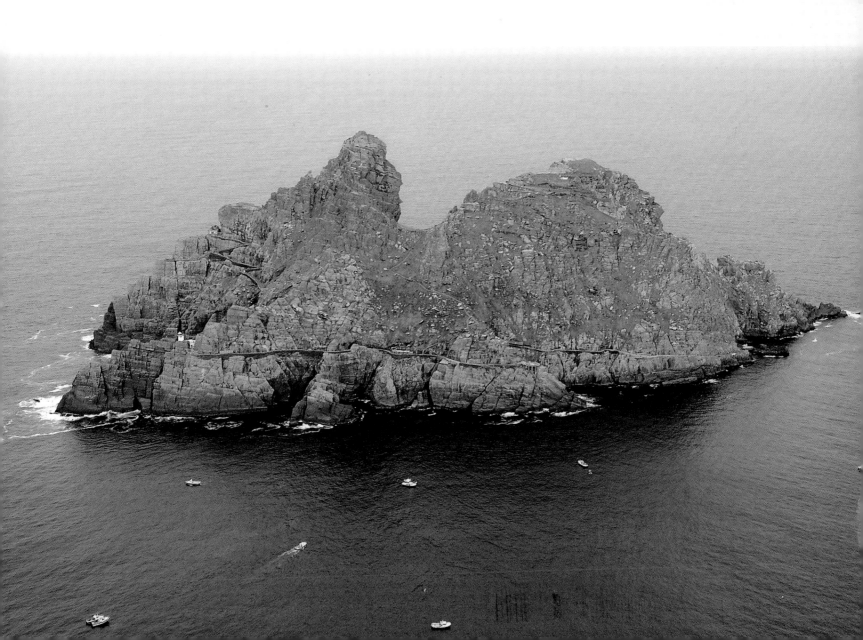

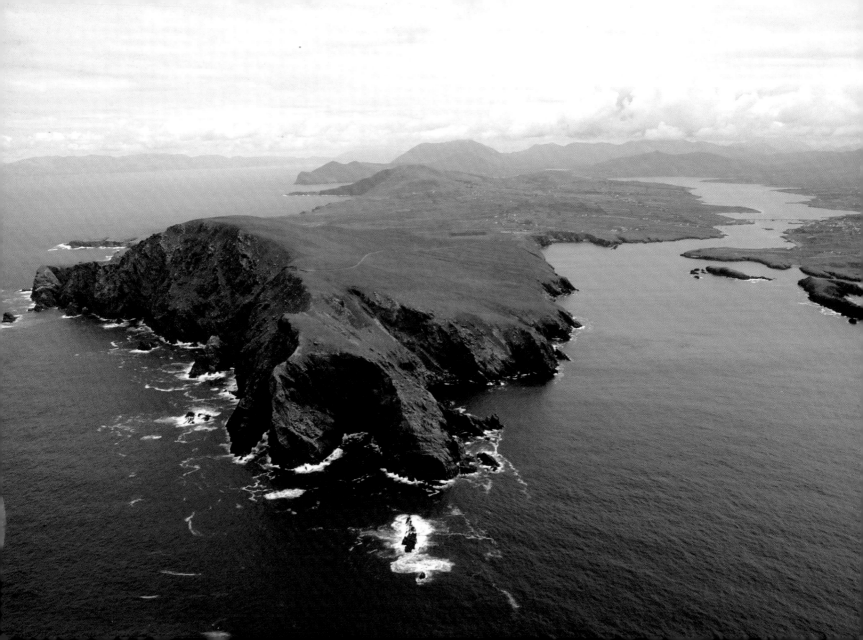

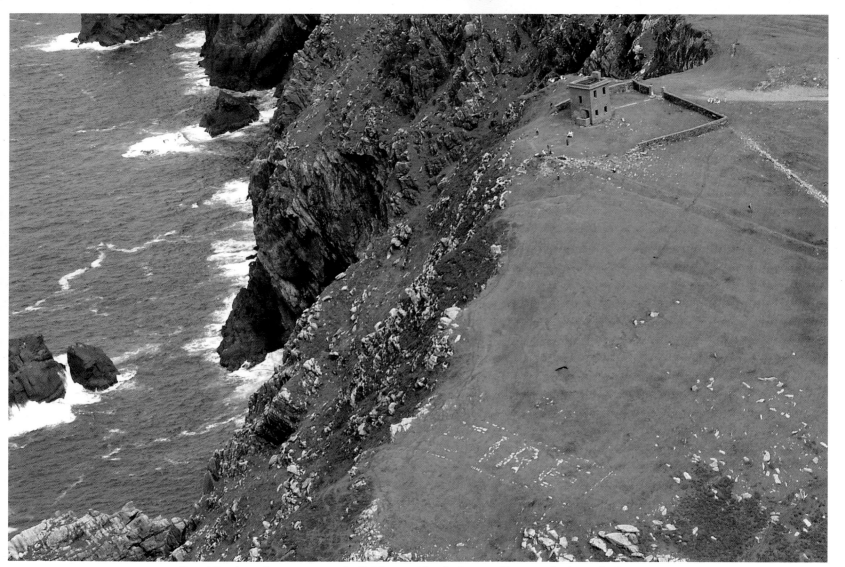

Bray Head on the western end of Valentia Island, County Kerry, and *above*, the letters
EIRE on Bray Head, depicting Ireland's neutrality during the Second World War.

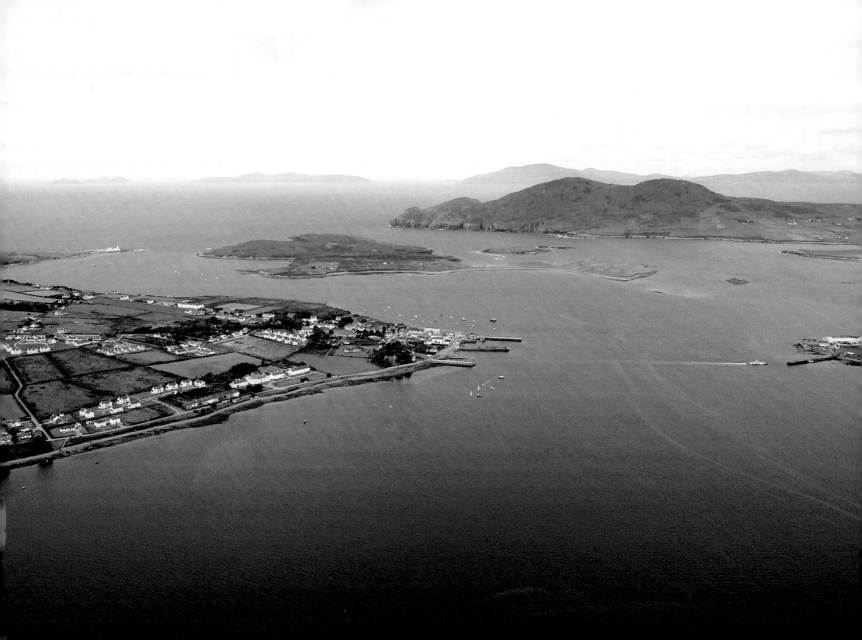

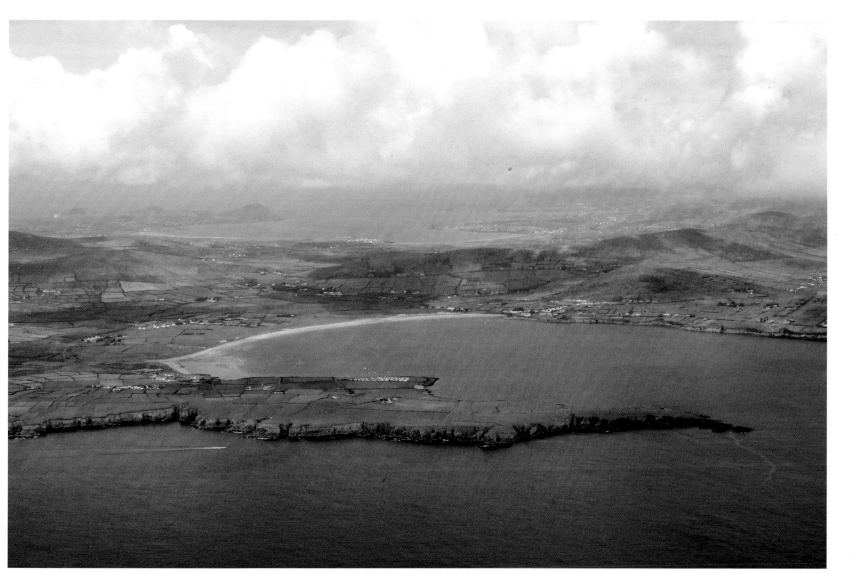

Knightstown overlooking Valentia harbour, with the car ferry just reaching Reenard Point, Cahersiveen, County Kerry. *Above*, Ventry Harbour near Dingle, County Kerry.

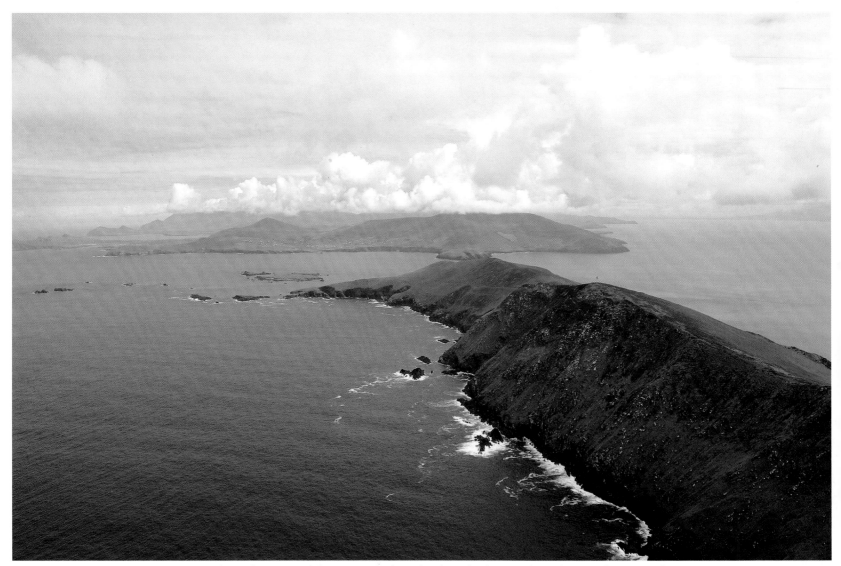

A view along the spine of the Great Blasket Island, with Slea Head on the Dingle Peninsula in the distance. *Right*, the Blasket islands and adjoining rocks, County Kerry.

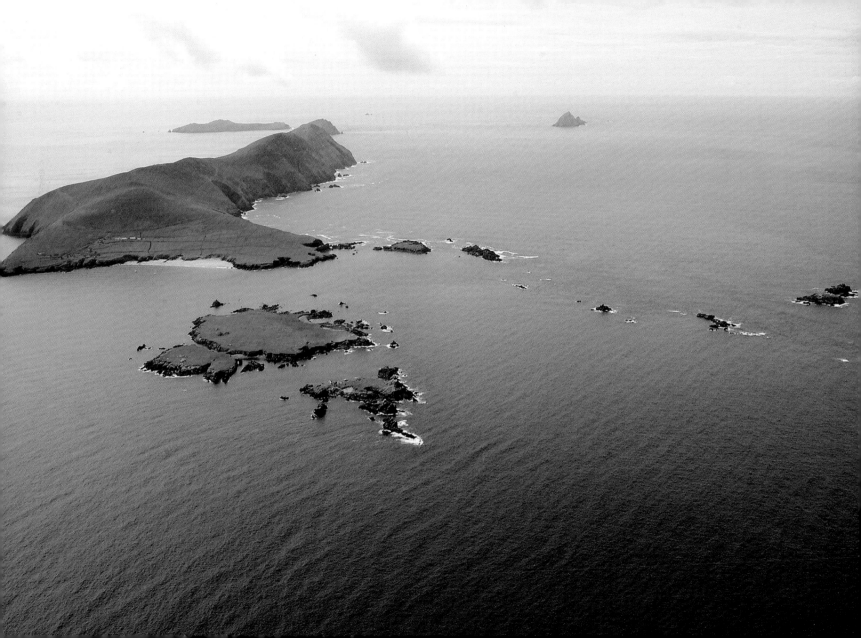

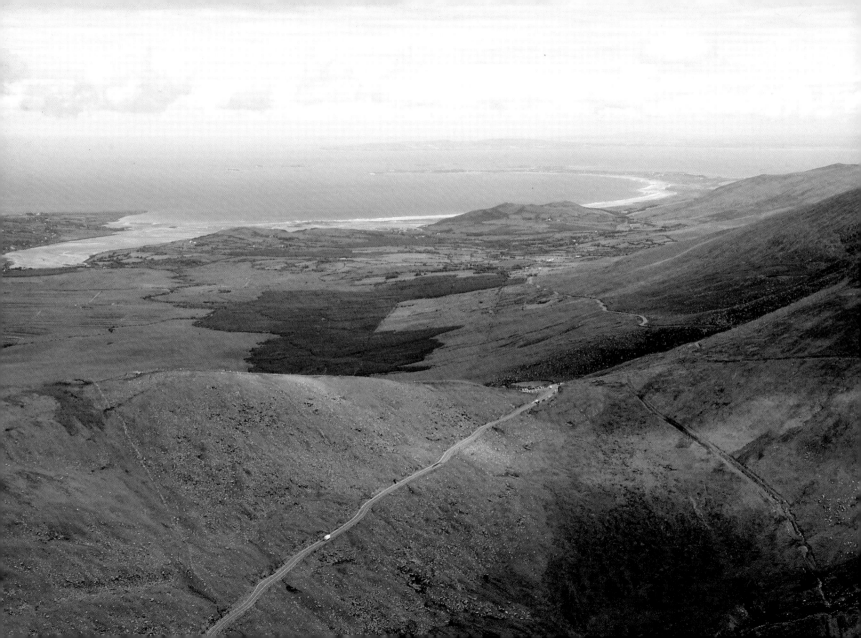

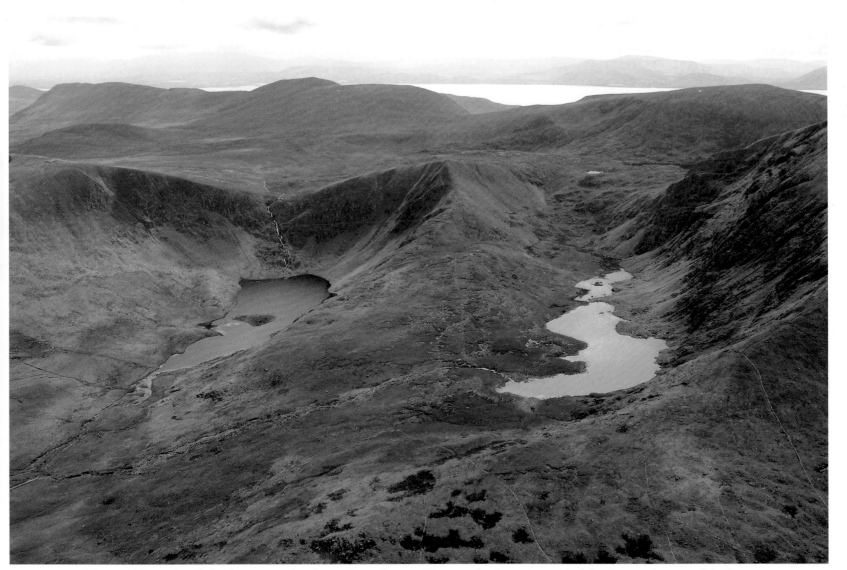

The road from Dingle leading up to the Conor Pass, County Kerry, and, *above*, mountain lakes just to the east of the Pass.

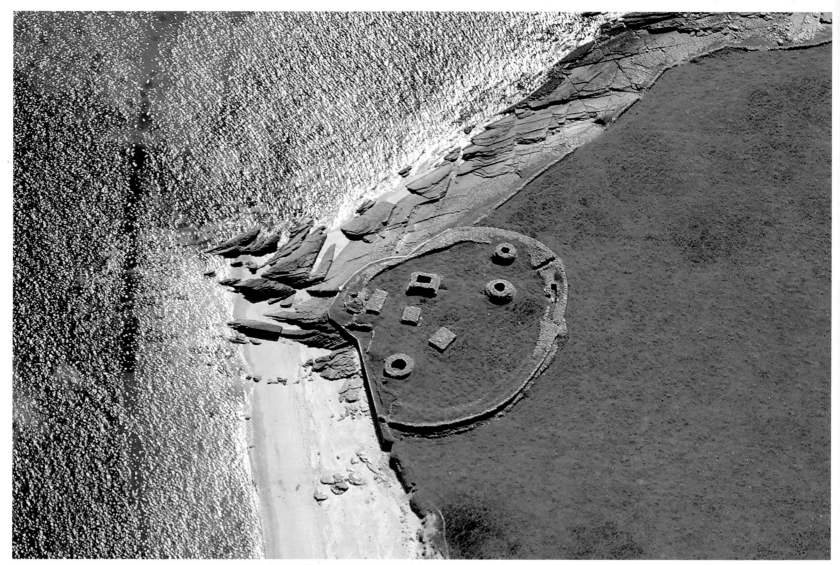

A monastic site on Illauntannig, one of the Magharee Islands north of the Dingle Peninsula. *Right*, the seaside holiday town of Ballybunnion, County Kerry.

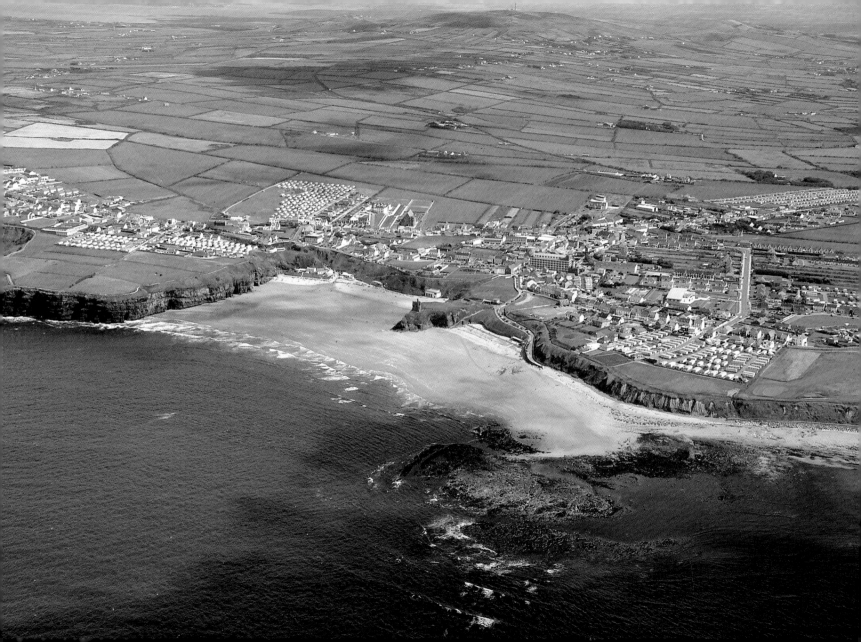

Leaving the Kingdom behind me, I am reminded that a day out of Kerry is a day wasted.

Clare, Connemara and Islands

I skirt the edge of County Clare with a glimpse of Kilrush Creek and a rocky field on the edge of the Burren. My wandering then takes me to Connemara and a wide diversity of sights.

In the 1850s the three-mile-long Cong Canal was built to link Lough Corrib in County Galway with Lough Mask in County Mayo. The canal was a failure because of its inability to hold water.

The harbours of Rossaveal, Roundstone and Clifden pass by, leading to islands on the edge of the Atlantic Ocean.

Inishbofin, County Galway, reveals a newly dredged channel in Bofin Harbour, a refurbished quayside and runway for the island. Inishturk passes by off the coast of County Mayo, and Clare Island presents itself looking beautiful from the east.

I see Keem Bay near the southwest corner of Achill Island and Clogham Cliffs, the highest in Ireland and third highest in Europe.

Finishing my visit to County Mayo, I pass close to Inishbiggle and finally the northern end of the Mullet Peninsula.

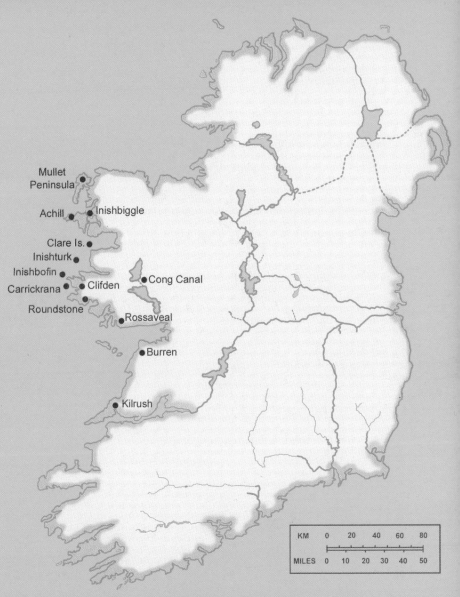

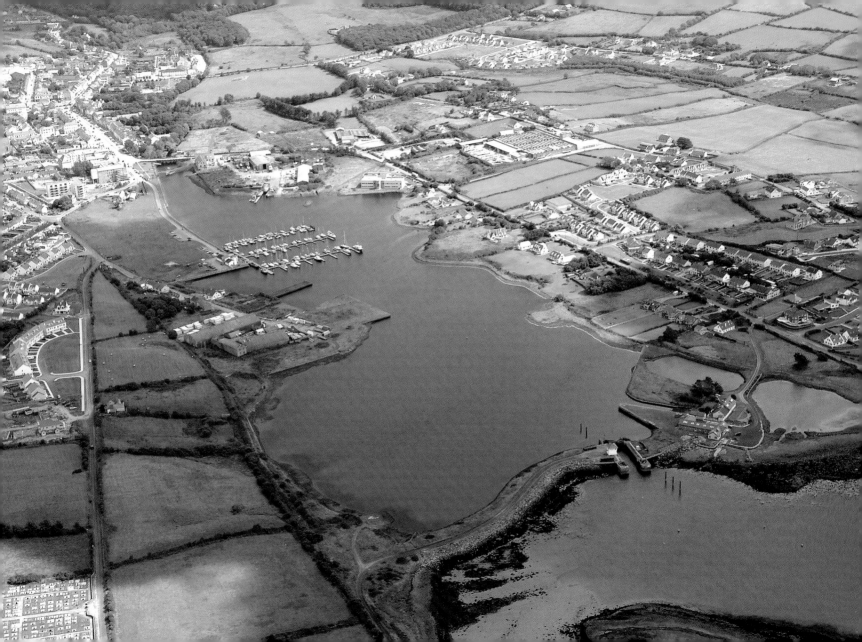

The town of Kilrush, on the estuary of the River Shannon.
Above, fields of rock on the edge of the Burren in County Clare.

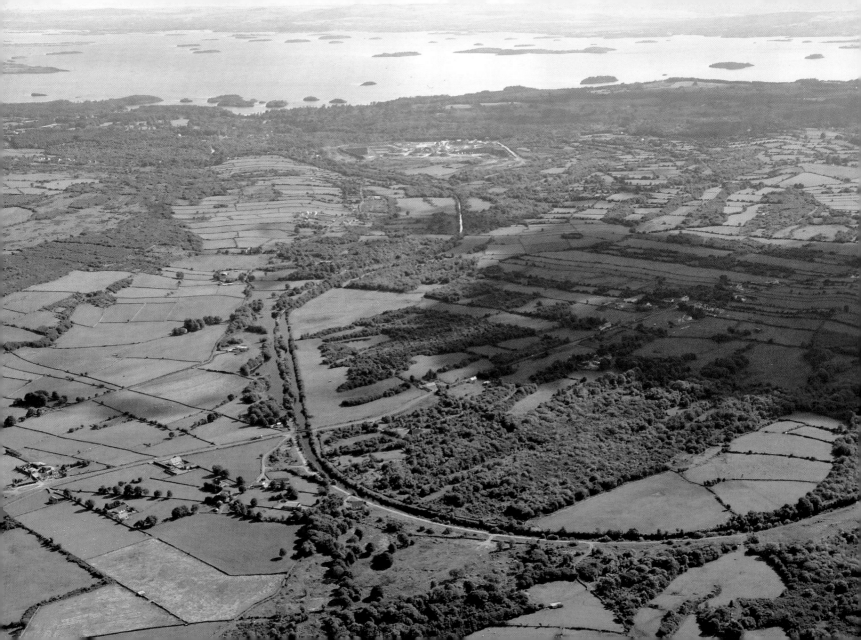

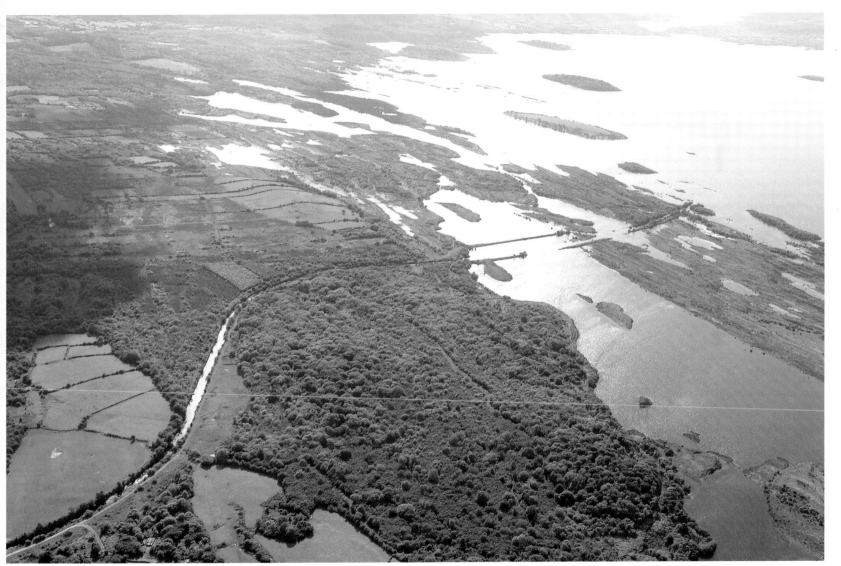

The three-mile long Cong Canal built in the 1850s with the intention of linking Lough Corrib with Lough Mask and, *above*, the canal seen leaving Lough Mask. It was a failure because of its inability to hold water and is also known as the 'Dry Canal'.

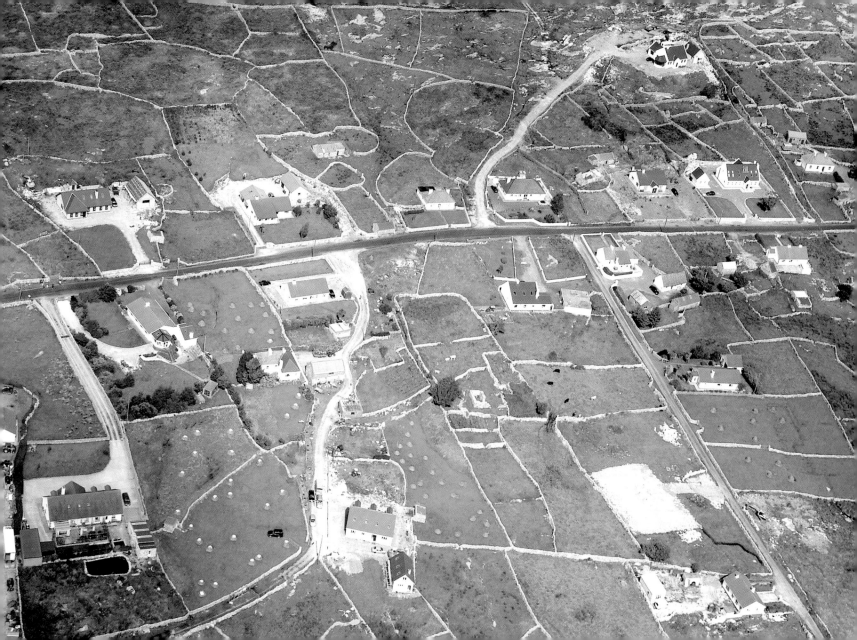

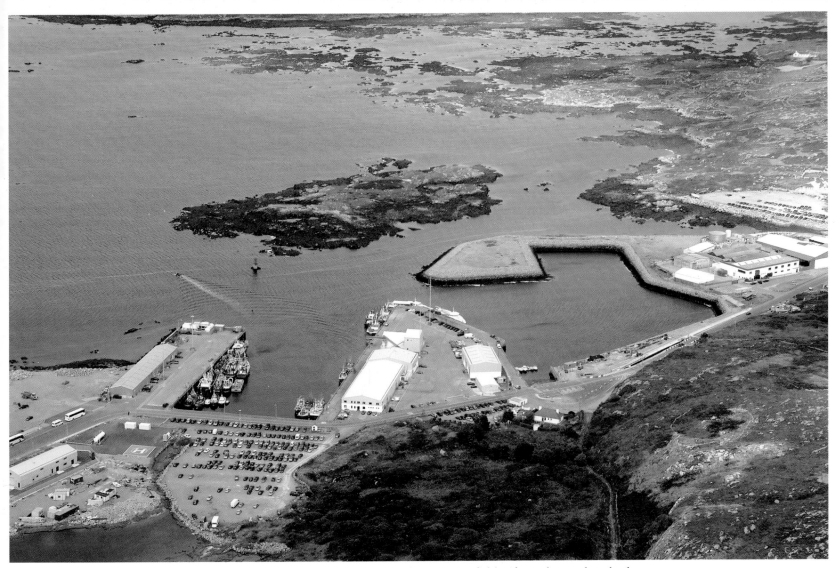

Housing, Connemara-style: a house in almost every field! *Above*, the modern harbour
at Rossaveal, County Galway, from where ferries ply to the Aran Islands.

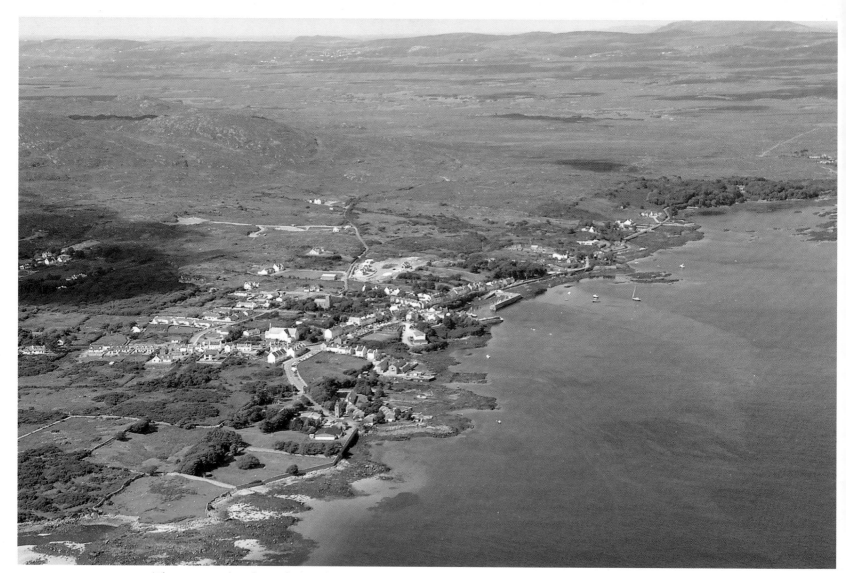

The western shoreline of Roundstown Bay in County Galway with Roundstone village and harbour.
Right, yachts moored in Clifden Bay, with the town in the distance.

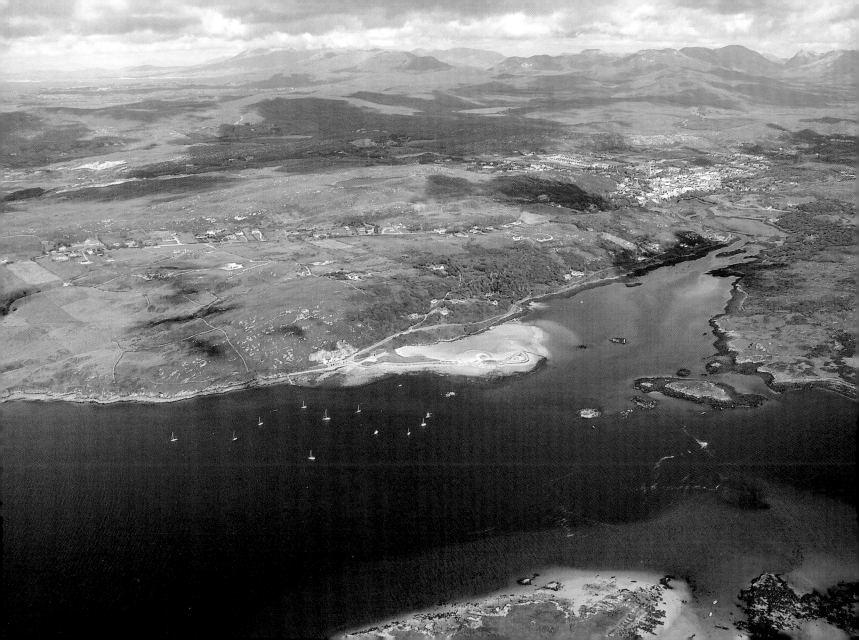

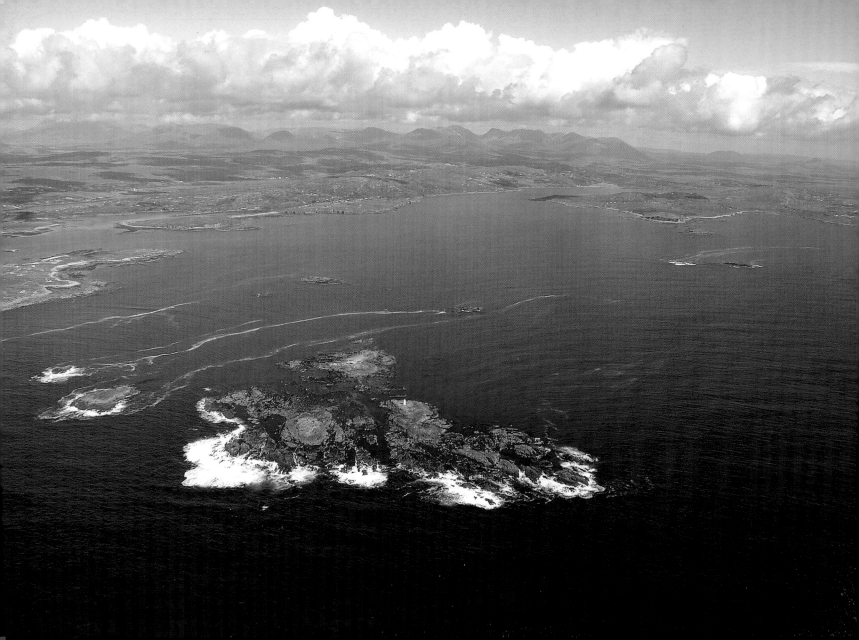

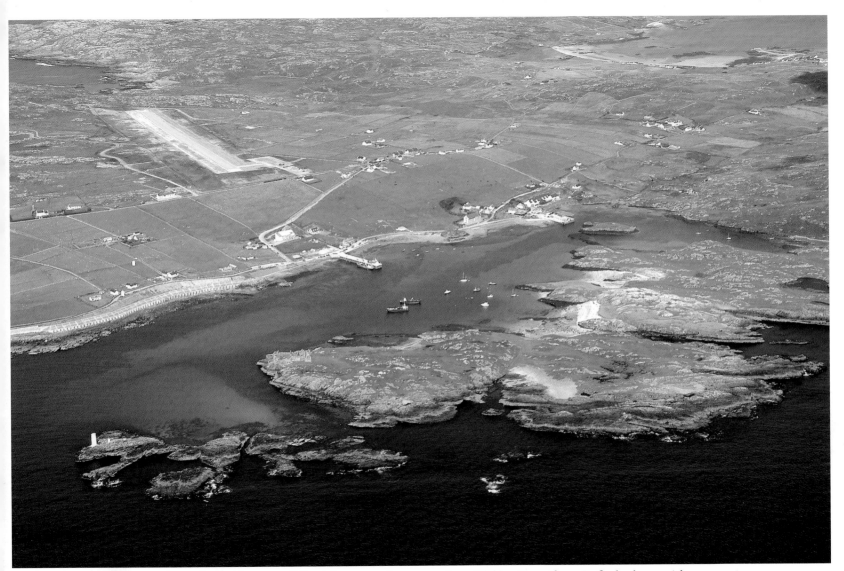

The rocks and beacon of Carrickrana on the approach to Clifden Bay. *Above,* Bofin harbour with dredged channel and refurbished quay and a new runway on Inishbofin Island, County Galway.

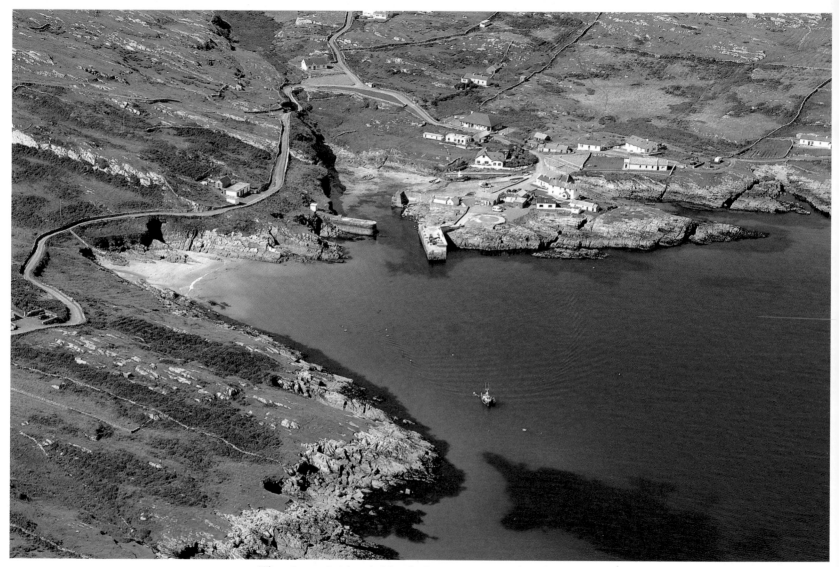

The pier on Inishturk Island, County Mayo and, *right*, the beautiful sight of Clare Island in Clew Bay, County Mayo.

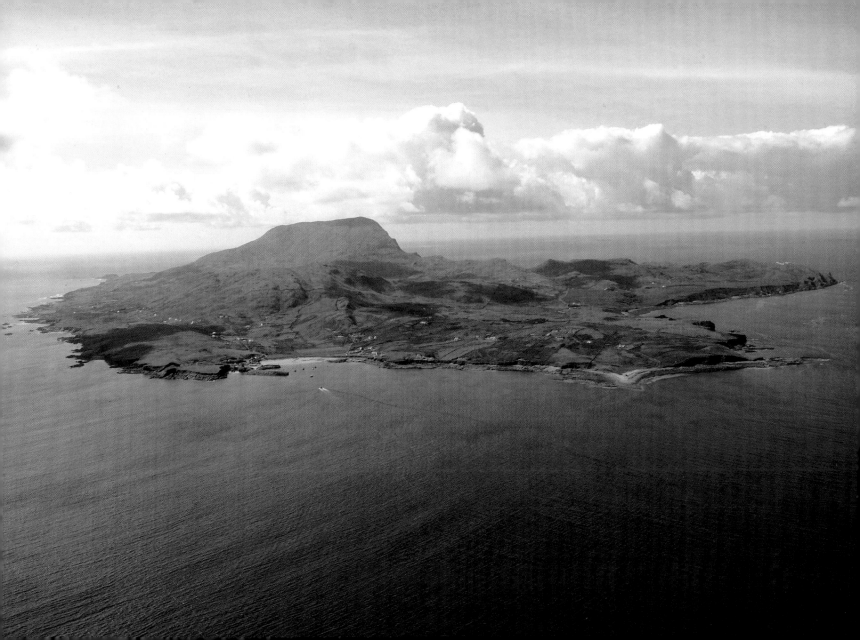

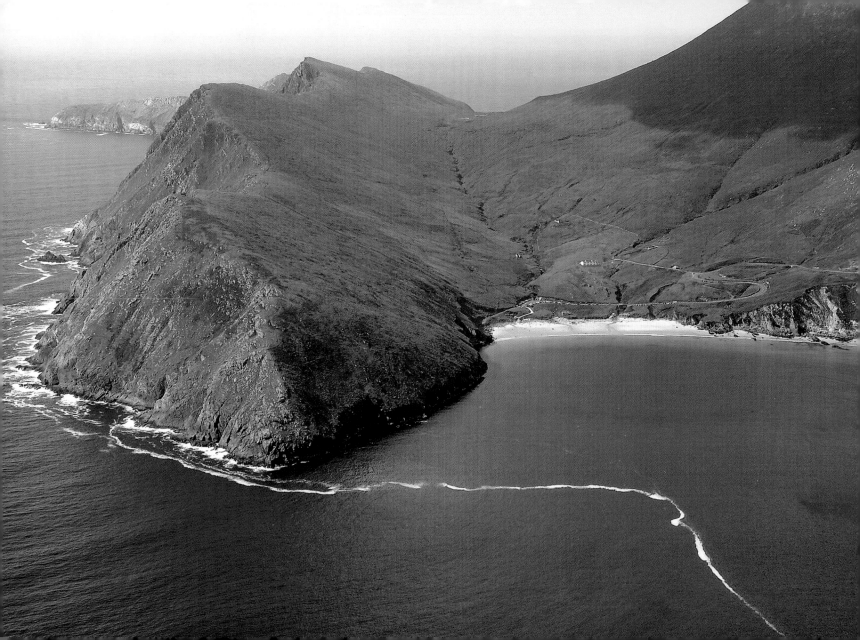

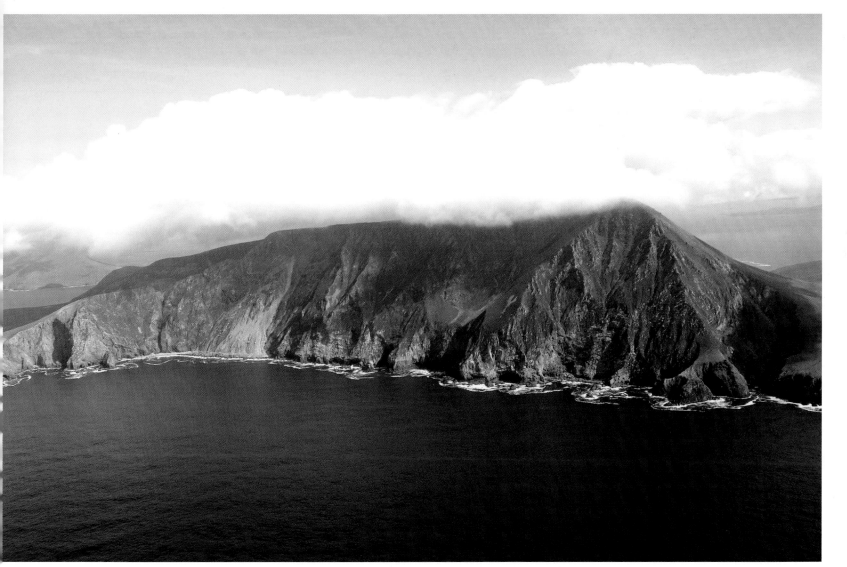

Keem Bay near the southwestern corner of Achill Island, County Mayo. *Above*, Croaghaun Cliffs,
Achill Island, the highest cliffs in Ireland and third highest in Europe.

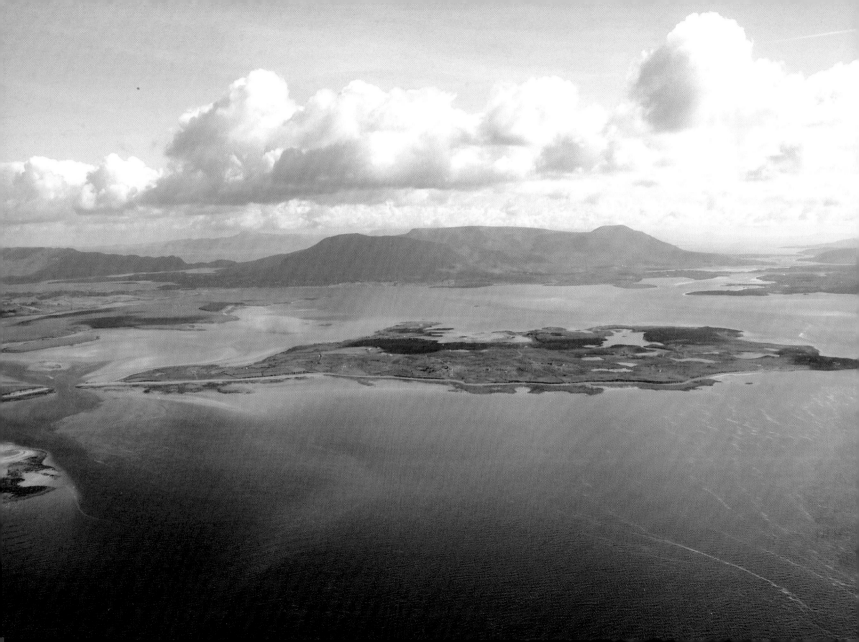

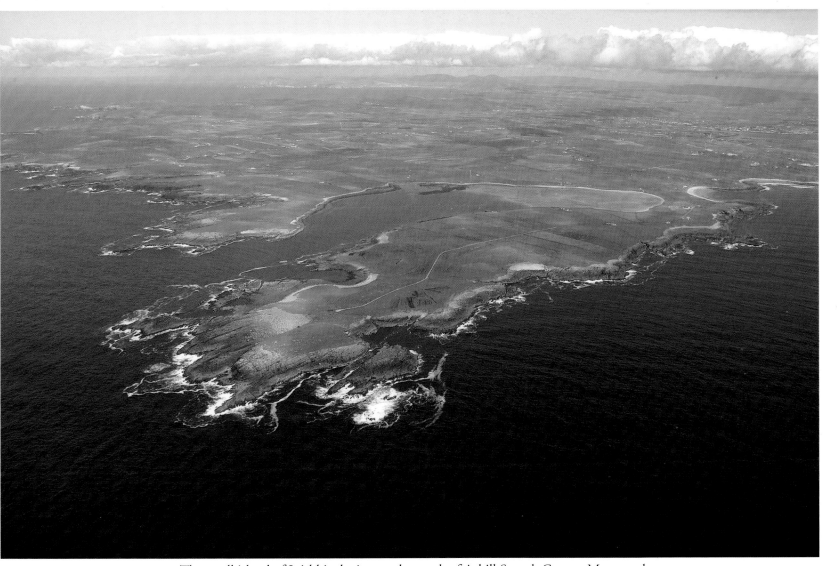

The small island of Inishbiggle, just to the north of Achill Sound, County Mayo, and, *above*, the inlet of Portnafrankagh near the northern end of the Mullet Peninsula.

Up North and to Dublin

EN ROUTE between Donegal and Dublin I was caught unexpectedly by the incredible sight of St Patrick's Purgatory looking as if it was floating on Lough Derg, County Donegal. The traditional date of the origin of the pilgrimage is 445 AD when St Patrick visited Station Island. The importance in medieval times is recorded by the fact that the lake is the only Irish site named on a world map of 1492.

Donegal reveals some of the most beautiful beaches in Ireland, and then Tory Island off our northwest shore.

Over Malin Head, County Donegal, another example of EIRE lettering from the Second World War appears, much clearer on this occasion. Then on to Inishtrahull Island, Ireland's most northerly landfall where the entire population evacuated the island in 1929 when the fishermen could no longer sustain a living.

I wander over Lough Foyle and follow the river to Derry, then a bit east along the Lower Bann as it passes Coleraine. On the horizon there is a suggestion of the island of Islay off the coast of Scotland some thirty miles away.

Warrenpoint, County Down, and Drogheda, County Louth, pass by before our final destination, the other capital of Ireland – Dublin.

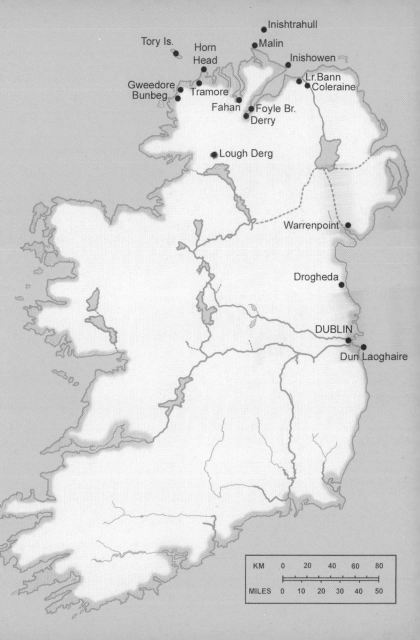

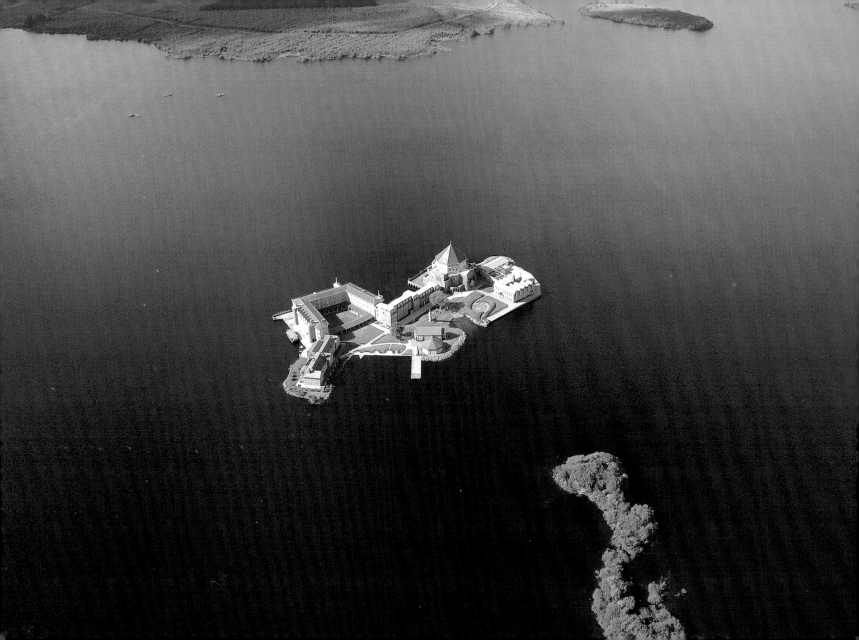

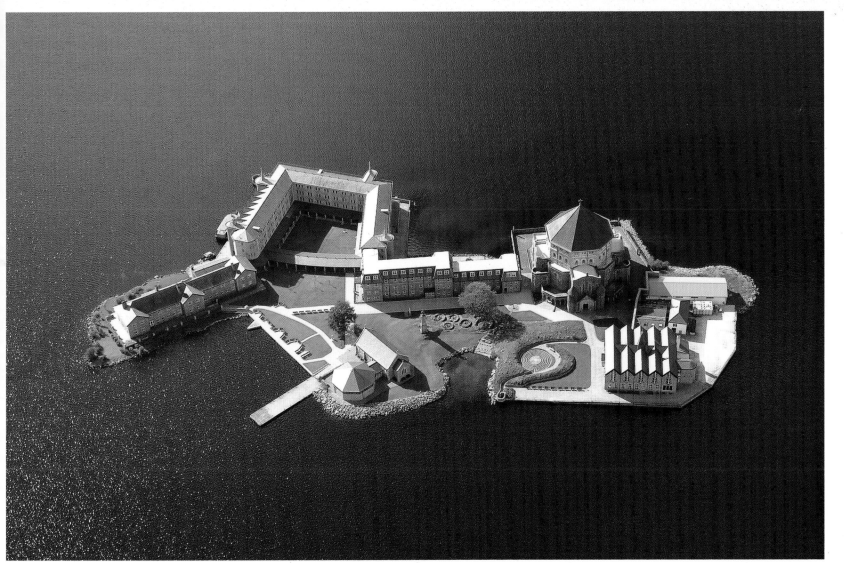

Station Island, Lough Derg, County Donegal, a place of pilgrimage dating from 445 AD when St Patrick visited the lake. *Above*, a closer look at St Patrick's Purgatory. Its importance in medieval times is recorded by the fact that the lake is the only Irish site on a world map of the 1490s. *103*

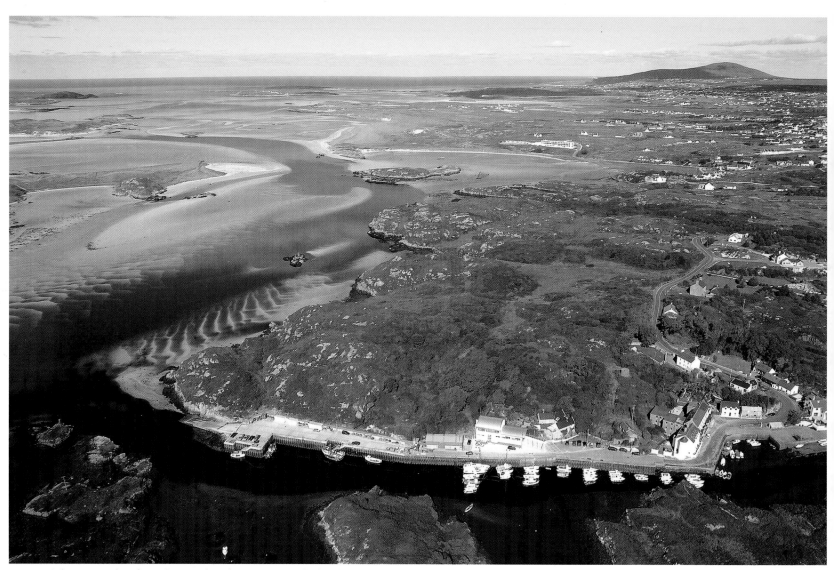

The quayside of Bunbeg with a distant view of Bloody Foreland Hill. *Right*, looking south with Gweedore harbour leading to Bunbeg.

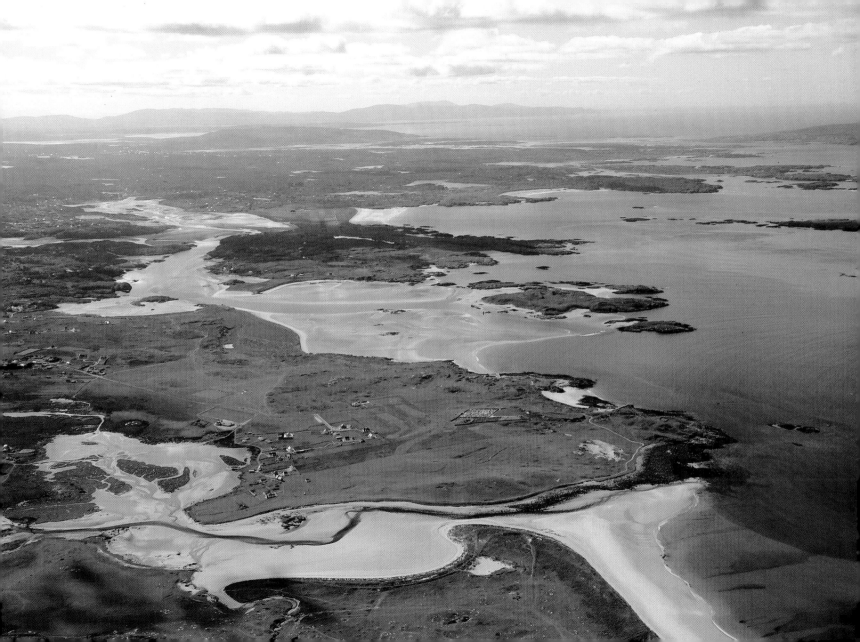

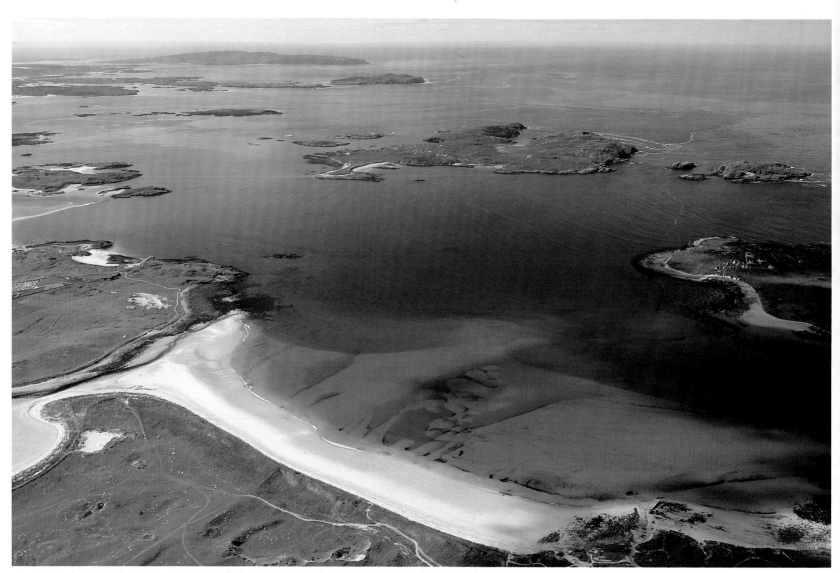

The ever-changing coastline of County Donegal with the island of Gola in the centre and Aranmore in the distance. *Right*, Tramore Strand, Dunfanaghy, on the northern shores of Donegal, one of the most beautiful stretches of golden sand on the island of Ireland.

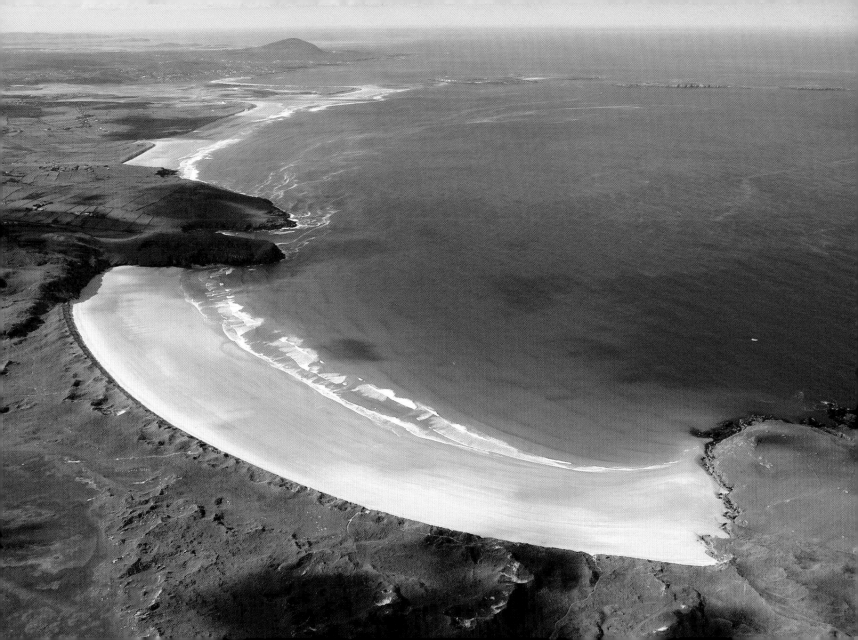

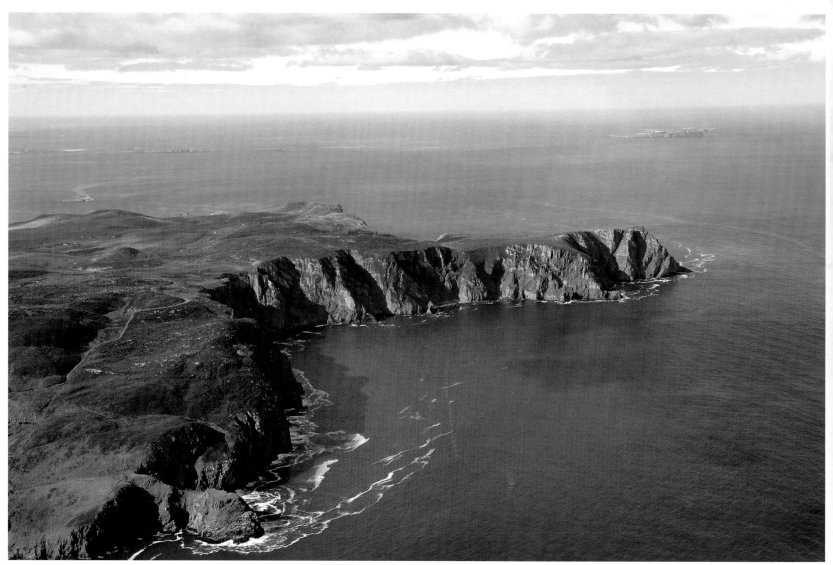

Horn Head at the northern end of Dunfanaghy Bay, County Donegal.
Right, looking down on Port Doon at the eastern end of Tory Island.

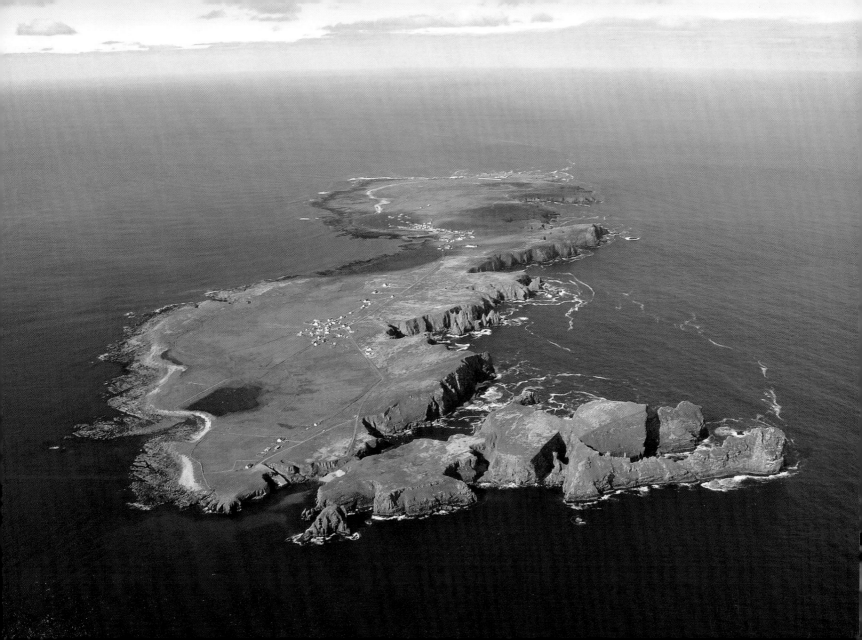

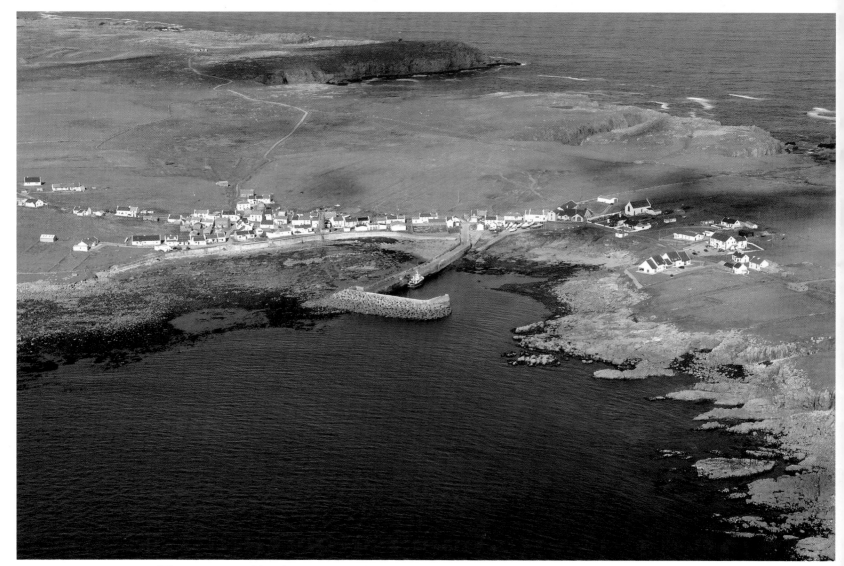

The new pier and breakwater at West Town in Camusmore Bay on Tory Island, County Donegal, and, *right*, the lonely lighthouse on the northwestern shoreline of Tory Island.

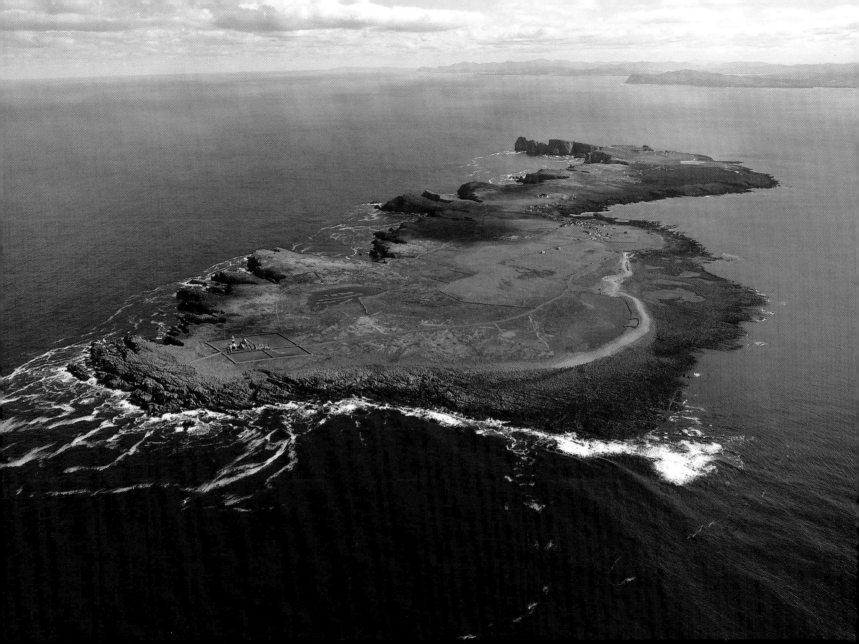

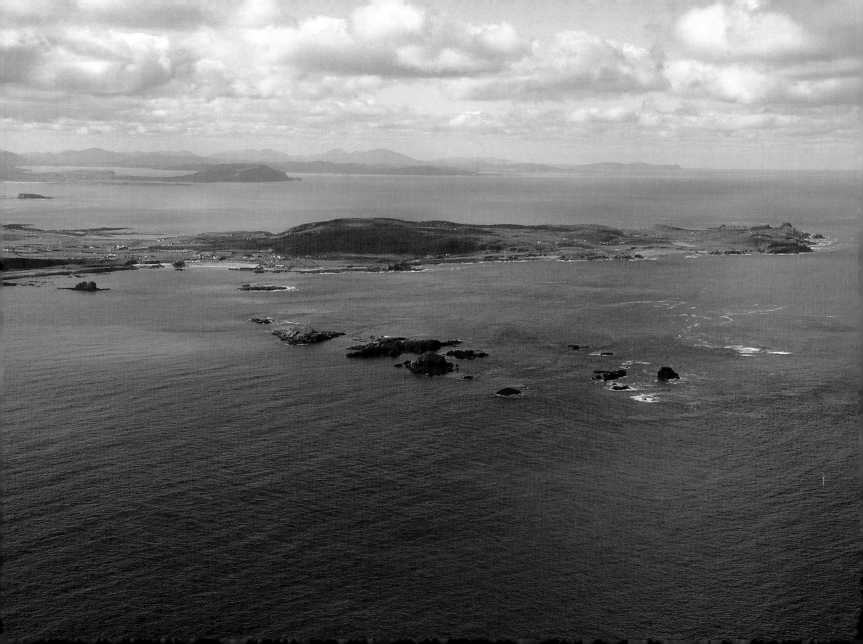

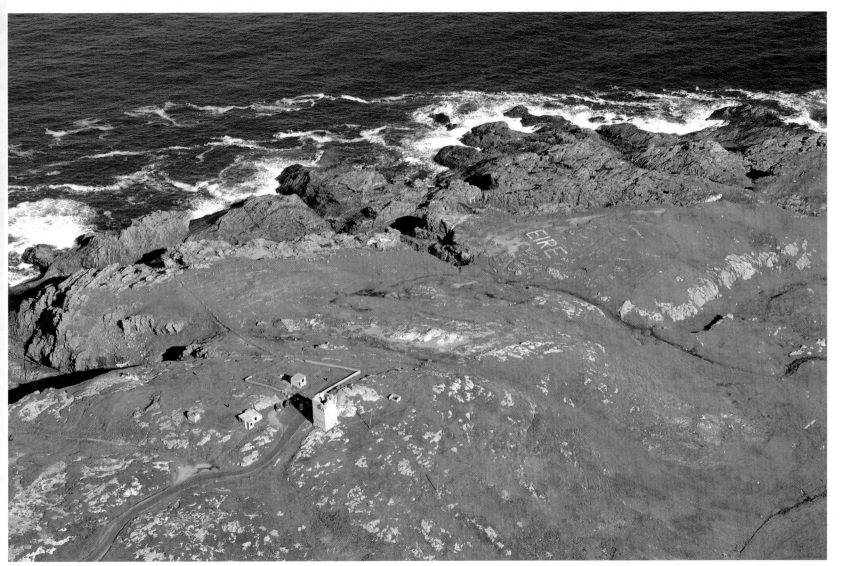

The rocky coastline beyond Malin Head, the northernmost headland on the island of Ireland. *Above*, markings to alert aircraft to neutral Ireland during the Second World War – EIRE clearly visible on Malin Head, County Donegal.

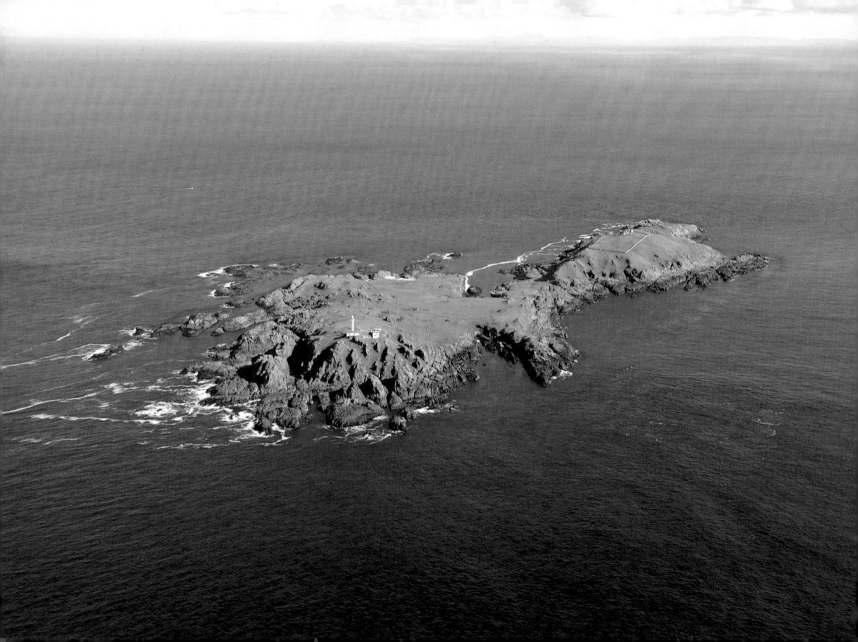

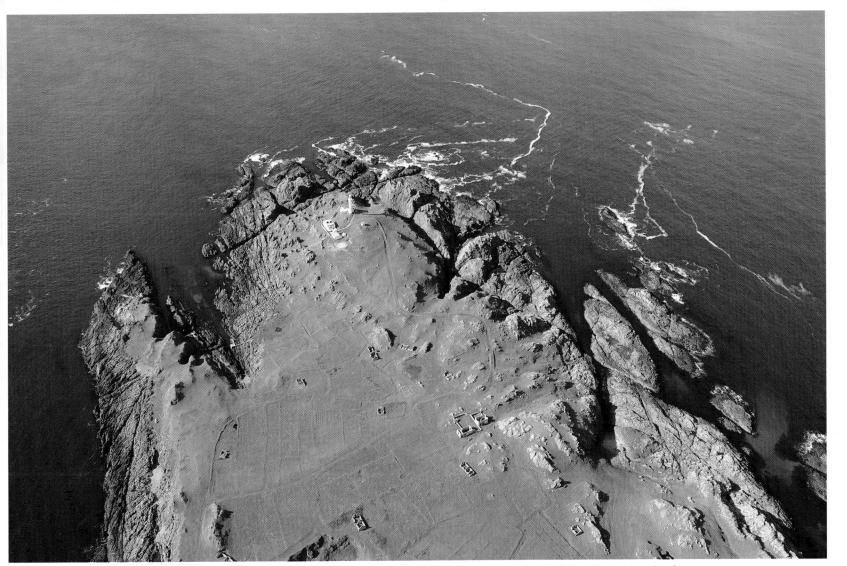

Inishtrahull Island, 10 km northeast of Malin Head, the most northerly landfall of Ireland and, *above*, the clear outline of fields and houses deserted by the population which evacuated Inishtrahull in 1929.

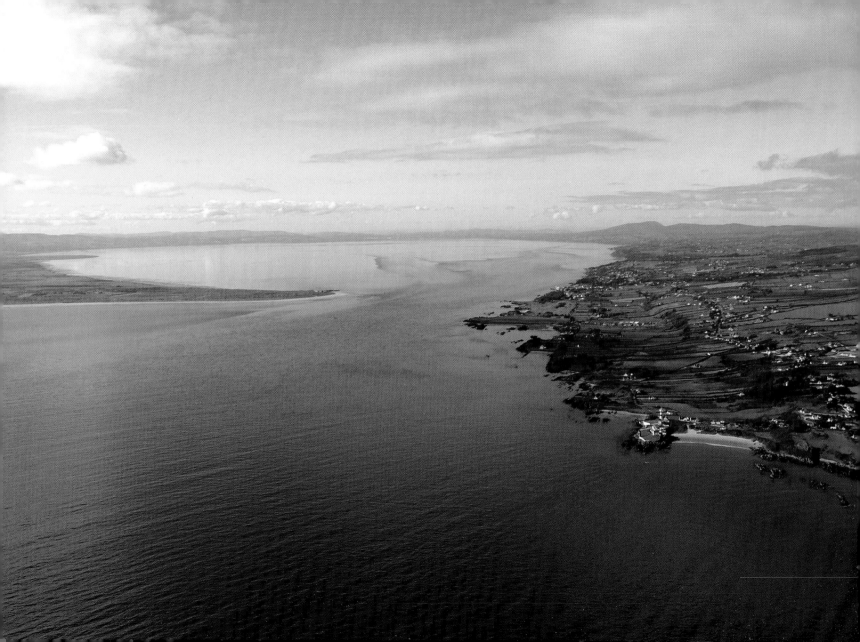

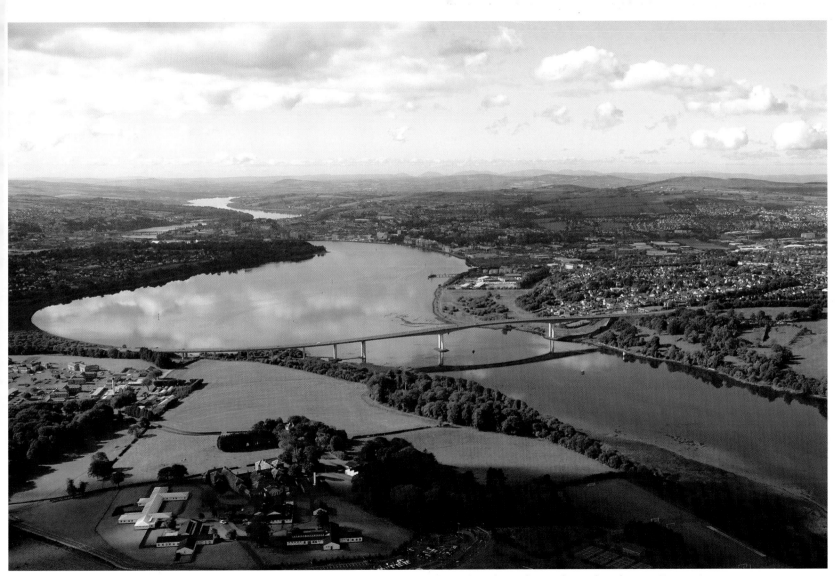

Inishowen Lighthouse, County Donegal, leading to Lough Foyle. *Above*, the Foyle Bridge close to Derry city.

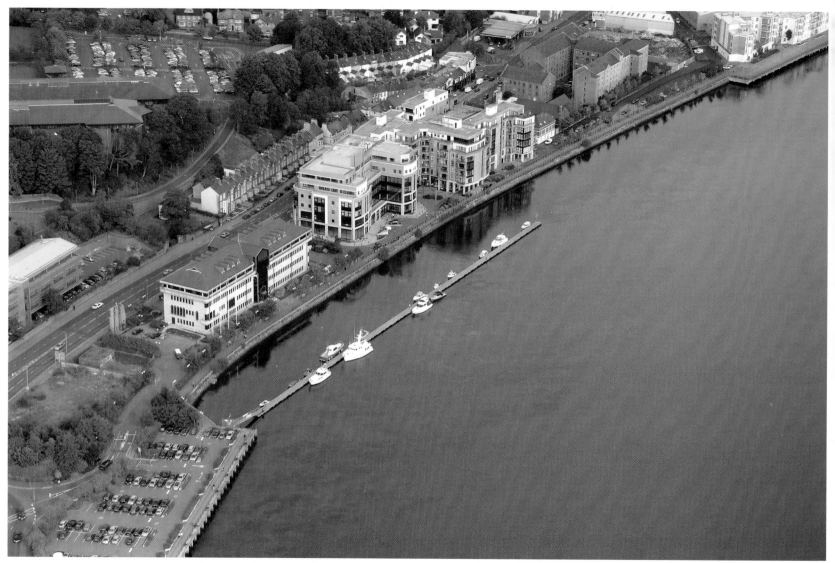

Pontoon for visiting boats in the heart of Derry and, *right*, Fahan Creek marina
on Lough Swilly, County Donegal, 14 km northwest of Derry.

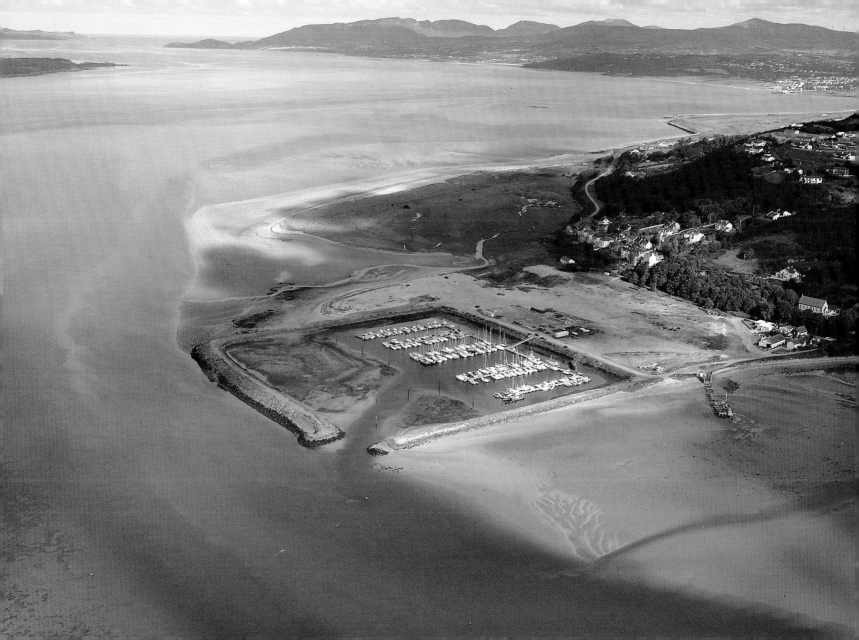

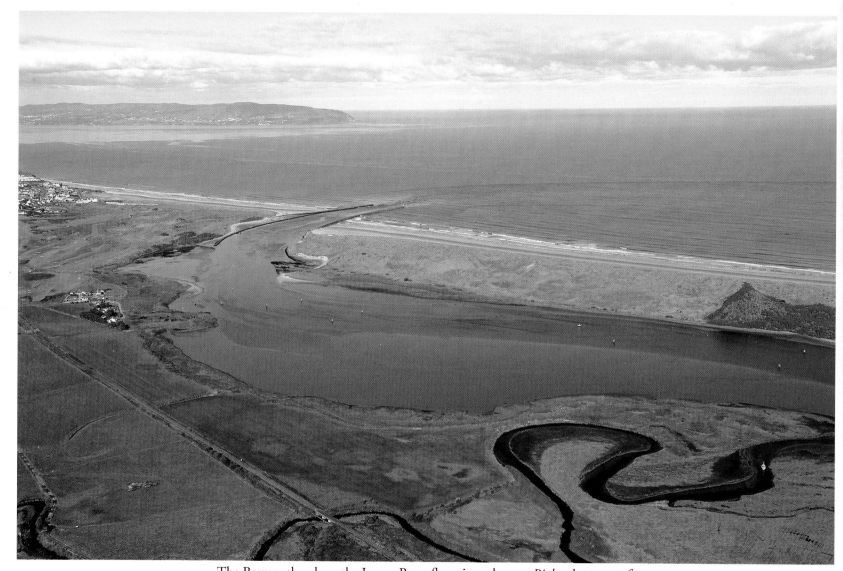

The Barmouth, where the Lower Bann flows into the sea. *Right*, the town of
Coleraine, County Derry, with the Scottish island of Islay on the horizon.

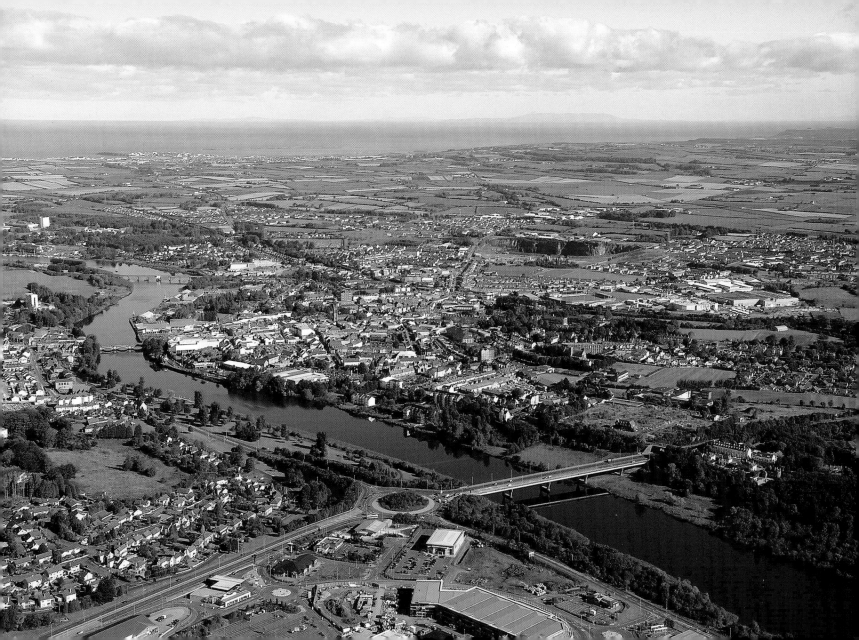

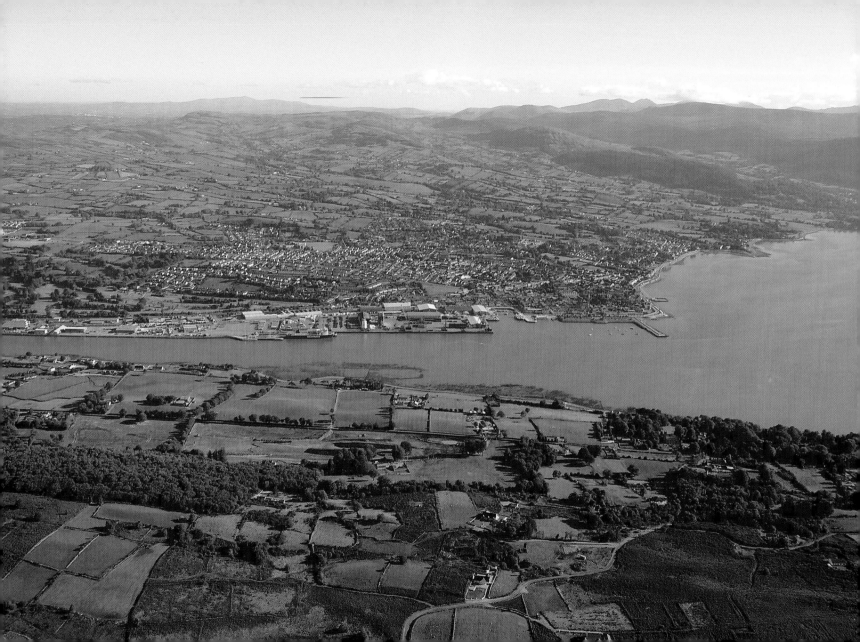

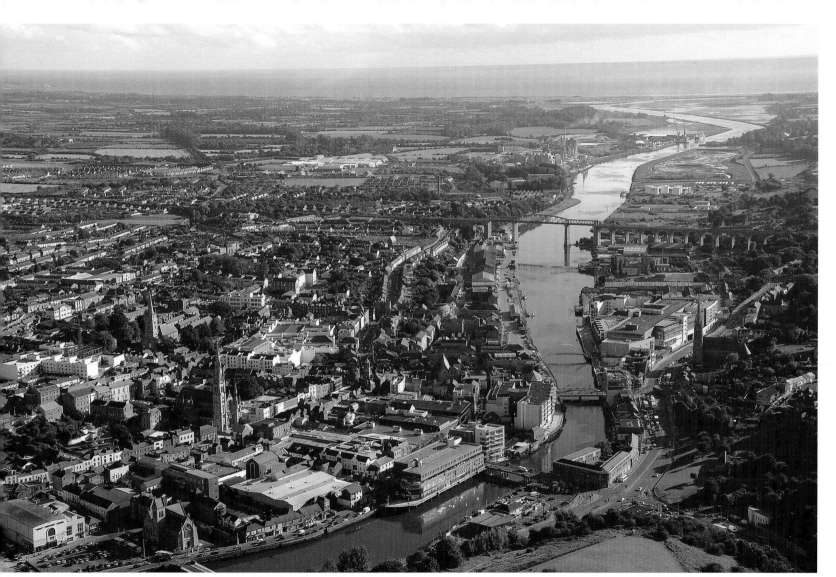

Warrenpoint, County Down, on the shoreline of Carlingford Lough with the Mountains of Mourne on the right-hand side. *Above*, the River Boyne flowing past Drogheda on its way to the Irish Sea.

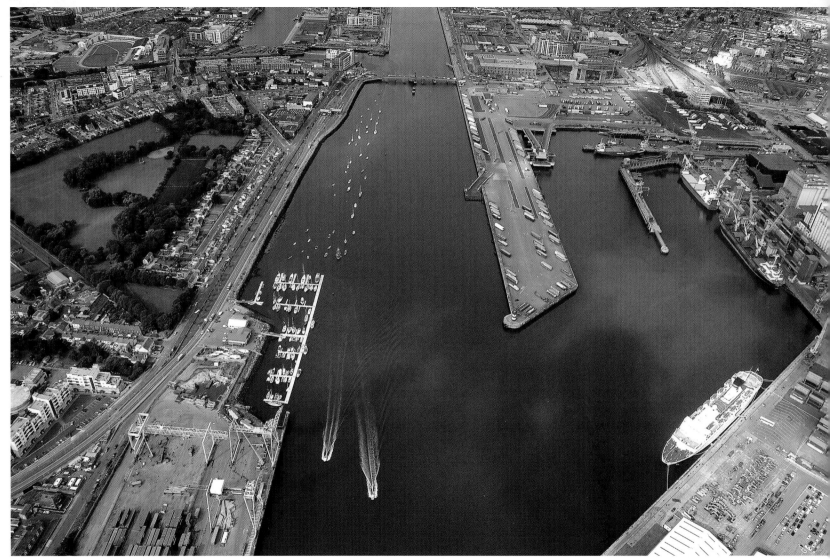

The River Liffey, Poolbeg Marina and part of Dublin Port and, *right*, 'Spot the Spike' – a closer look at the centre of the page reveals the Millennium Spike stretching 120 m above O'Connell Street, Dublin.

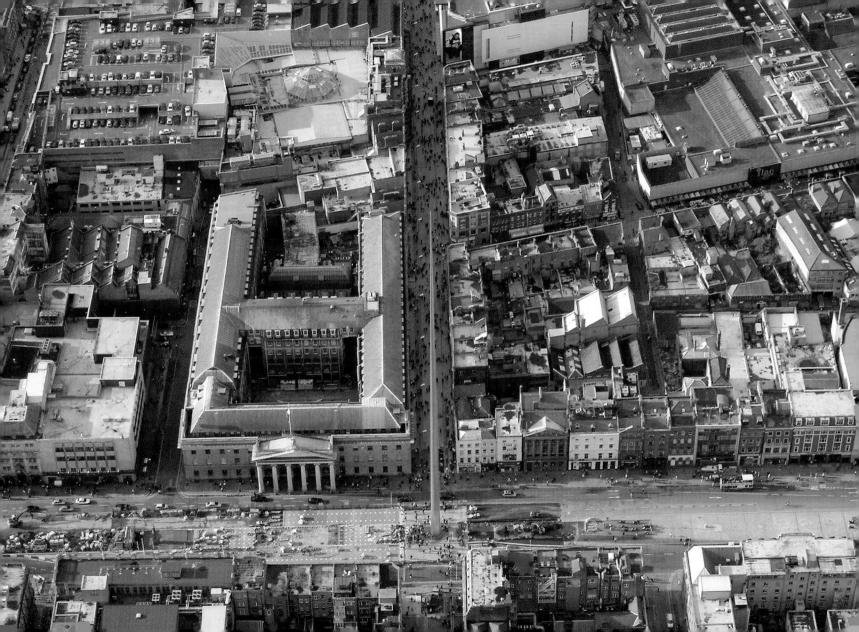

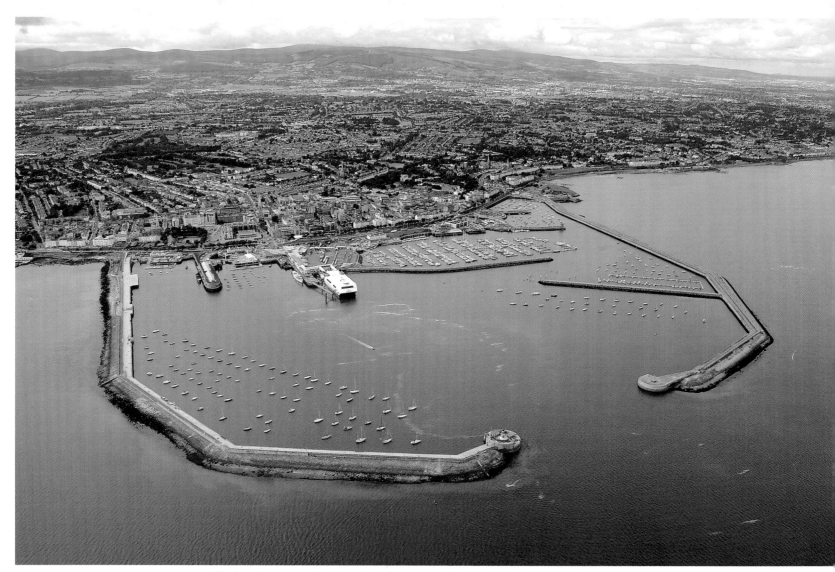

The bustling town, harbour and ferry port of Dun Laoghaire, County Dublin.

Index